How to Shoot Great Travel Photos

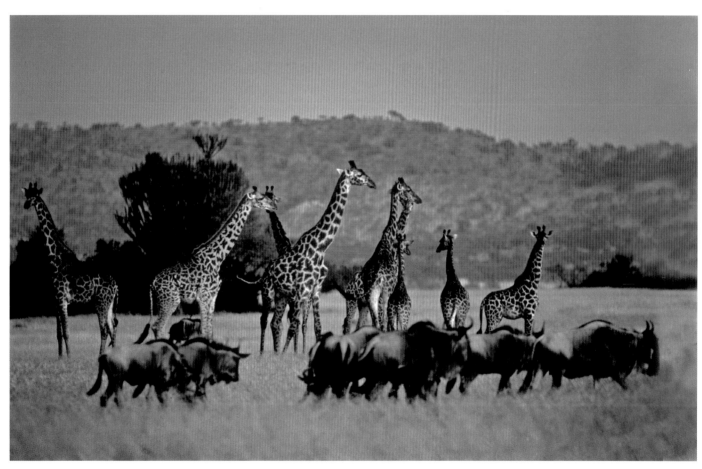

Giraffe and wildebeest, Serengeti, Tanzania, Africa. Nikon F-2 camera mounted on a tripod, 500mm fixed-aperture f/8 mirror telephoto lens, 64 ISO film. Exposure was 1/250 at f/8.

How to Shoot Great Travel Photos

Susan McCartney

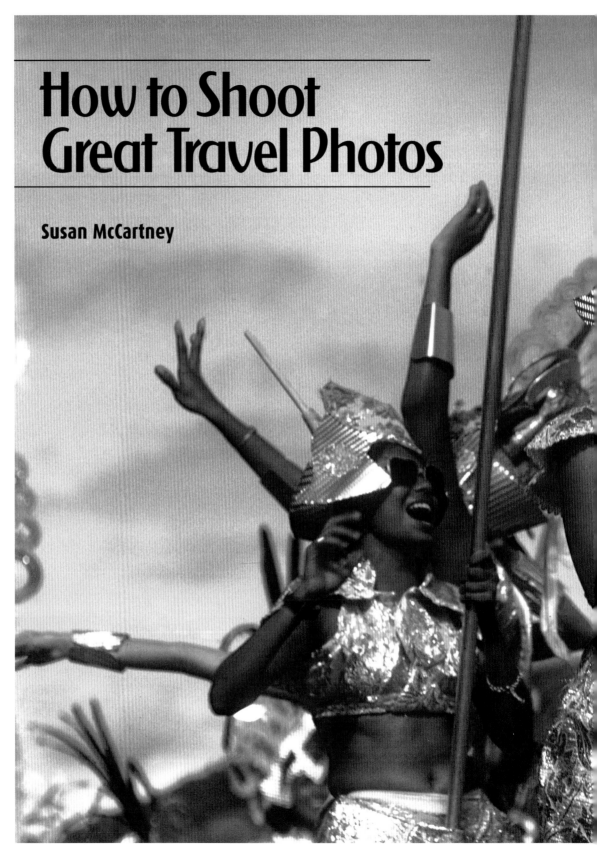

Carnival dancers, Port of Spain, Trinidad. F-2 camera, 80mm lens, 64 ISO film. Exposure was 1/250 at f/11.

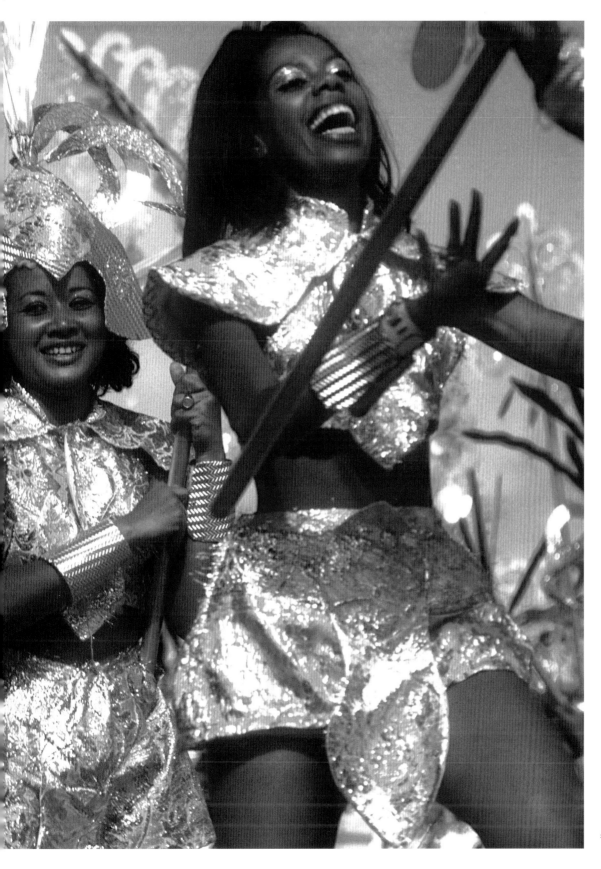

ALLWORTH PRESS
NEW YORK

ACKNOWLEDGMENTS

I would like to thank Patricia and Napier Collyns, Ricardo de Mattos, Karol DuClos, Joe Farace, Patricia and Wayne Fisher, Kerynn Fisher, David Lida, Irwin Miller, Caroline Nye, John O'Leary, Patricia Poullain, Barbara Steffen, Betty Werther, and Ellis Vener. You have all helped in different ways. I would also like to sincerely thank my long suffering editors, Nicole Potter and Jessica Rozler, my publisher Tad Crawford, and the other nice people at Allworth Press, all of whom are forgiving about my lateness. Last, but not least, many thanks to Charlie Sharp and Derek Bacchus, who designed the book and cover, respectively.

07 06 05 04 03 5 4 3 2 1

Published by Allworth Press
An imprint of Allworth Communications, Inc.
10 East 23rd Street, New York, NY 10010

Cover design by Derek Bacchus
Page composition/typography by Sharp Des!gns, Lansing, MI

ISBN: 1-58115-326-0

LIBRARY OF CONGRESS CATALOGING-IN-PUBLICATION DATA
McCartney, Susan.
How to shoot great travel photos / Susan McCartney.
p. cm.
Includes bibliographical references and index.
ISBN 1-58115-326-0 (pbk.)
1. Travel photography—Handbooks, manuals, etc. I. Title.
TR790.M3797 2004
778.9'991—dc22
2004022632

Printed in Thailand

Contents

About the Author

Inspired by her mother, who took many pictures during her travels as an actress, Susan took her first serious photographs at age twelve with a plastic twin lens reflex camera. She attended art schools in both London and New York, and took master classes from Richard Avedon, Hobart Baker, Alexy Brodovitch, Harold Kreiger, Melvin Sokolsky, and Walter Rosenblum. Stints as a United Nations guide and student travel officer for the British Tourist Authority gave her contacts in the travel industry, which she used when she became a professional photographer. Since then, she has shot all over the United States and the world for such diverse clients as Borde Failte Eireannean, British Airways, Caravan Tours, Lan Chile Airlines, Varig Airlines, the U.S. Army, the U.S. Post Office, and Warner Bros. Records. She has also provided images for *Travel Holiday*, *Travel and Leisure*, the *New York Times*, *Glamour*, *Woman's Day*, *Popular Photography*, *Shutterbug*, and other magazines. Her stock photographs have appeared all over the world. Susan lives in New York City and periodically teaches photography workshops. This is her sixth book.

Preface

I have written this book for anyone who shares two lifelong passions of mine: photography and travel. You don't have to be a photographic expert or even use the most advanced cameras; however, you *do* have to be an enthusiast to take advantage of the information in this book. I've tried to demonstrate everything visually, and the plain-English text supplements the pictures with factual data.

I recommend the gear I currently use, plus other good stuff too.

I'll suggest places where you are almost guaranteed to be able to make great pictures, and give sources for future travel ideas. Of course I have included my choice of government, travel industry, and other helpful Web sites to help you research destinations and events as well as get the latest available information on fares, good travel deals, and up-to-the-minute security issues. My favorite guidebooks and a manufacturers' resources list are provided as well.

Whatever your level of experience and photographic goals when you travel, you can't just occasionally stick one hand with a point-and-shoot out of the car window if you hope to take great pictures. You will need time to concentrate on photography. Ideally, devote some time each day purely to visual exploration; the more you photograph and explore, the better your pictures will be. Those with professional aims will work from dawn to dusk, and even at night on occasion. But, photography should be fun, so approach it at your own pace. I wish you creative satisfaction, fun travels, and success on your own terms.

SUSAN McCARTNEY
New York City, Fall 2004

INTRODUCTION
A Brief Overview

Good travel photography is simply good photography done in unfamiliar places. Great travel photographs are made by photographers who are in love with a subject, who have talent, passion, and a willingness to shoot and re-shoot if needed until they capture the images they see with their "inner eye."

No matter what or where you shoot, it usually helps to have a clear idea of your goals in advance rather than to snap away randomly. Serious travel photographers at any level of experience may start by making images with the intent of assembling a well-composed, edited, and sequenced story-telling album, or by putting together a slide show of a nearby favorite place, personal trip, or family vacation that won't put viewers to sleep.

Or, you can shoot for "wall art" or "fine art" and make enlargements of single pictures or a series of related images to decorate the walls of a home, school, office, or commercial gallery.

In either case, shoot plenty of pictures early and late, especially when the sun is out. Low light reveals texture.

To assemble interesting groups of pictures on a page or a Web site, or shots for an exhibit, vary the scale and distance from your subjects—including close-ups, medium, and far-distance shots—and be ruthless when you edit. Get rid of mistakes and cluttered or dull stuff, then refine your choices. Show only the best of two or three similar shots, or you risk boring people. Don't forget we are all accustomed to watching fast-paced TV shows and movies. But don't prune too ruthlessly; be aware that today many interesting variations of "normal" images are routinely published. Also, know that some problems in otherwise good photos can be corrected by the careful use of computer retouching programs.

To improve your sense of composition and your photographic "eye," look at good photographs in magazines, books, newspapers, as well as originals in galleries. Look at great paintings whenever you can. I like to look at TV commercials with the sound turned off, since talented, highly paid visual artists work on these spots, and some of the lighting and other effects they achieve are spectacular.

If you have professional ambitions, be aware that all travel magazine and commercial travel images are made to "sell" a place and therefore must accentuate the positive. Don't show slums, poverty, or sad or unpleasant things that exist in all countries, including your own.

Some photographers work for many years toward the goal of publishing a travel or travel-related picture book. If that is your ambition, I heartily applaud you. It is the highest level of travel photography, one that I am still pursuing.

The more often you shoot, the more quickly your pictures, your reflexes, and your camera-handling skills will improve. Focus on what you love best whenever possible. Plan travel ahead, but be open to spontaneity on occasion. Give time and thought to the type of travel shoot you are

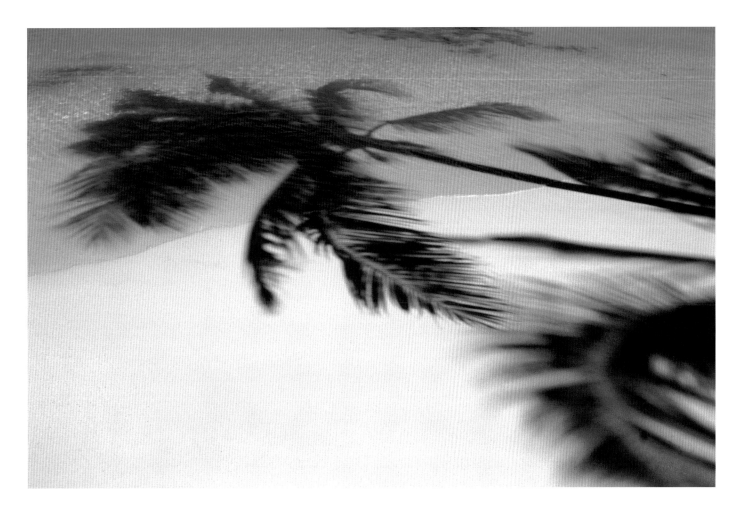

embarking on: personal, self-assigned, or commercial; far away or close to home. And, no shoot is done until the pictures are edited.

Shadows of palms on beach, Negril, Jamaica. Fuji S-2 digital camera, 100 ISO setting. At 8 AM, exposure was 1/250 at f/16 with a 20mm lens.

However professionally ambitious you may be, don't forget to shoot for fun or joy sometimes. Such pictures may turn out to be your best. Art is meant to be shared; show your best pictures to others, even if you are just starting to work seriously. Listen to creative criticism from those you respect, but never let discouraging comments deter you.

Serious travel photographers need many of the skills of the photojournalist, including excellent reflexes, a fine eye for light and composition, and the ability to relate well to all kinds of people. It's also a great asset to be able to create *mood*. To do this, you may want to emphasize the positive by setting up pleasant situations—without falsifying anything factual, of course. You could buy drinks in a pub, ask a good-looking couple to walk into a scene, treat kids to rides at a fair (with their parents' permission of course), add some flowers to a dining table—you get the idea.

Finally, do remember that it takes time and hard work to find a personal photographic "look" or style. If progress seems slow, shoot as often as you can and hang in there. You will get through the block sooner or later. And always remember that no matter what your ultimate ambitions for your travel images are, persistence pays off in the long run.

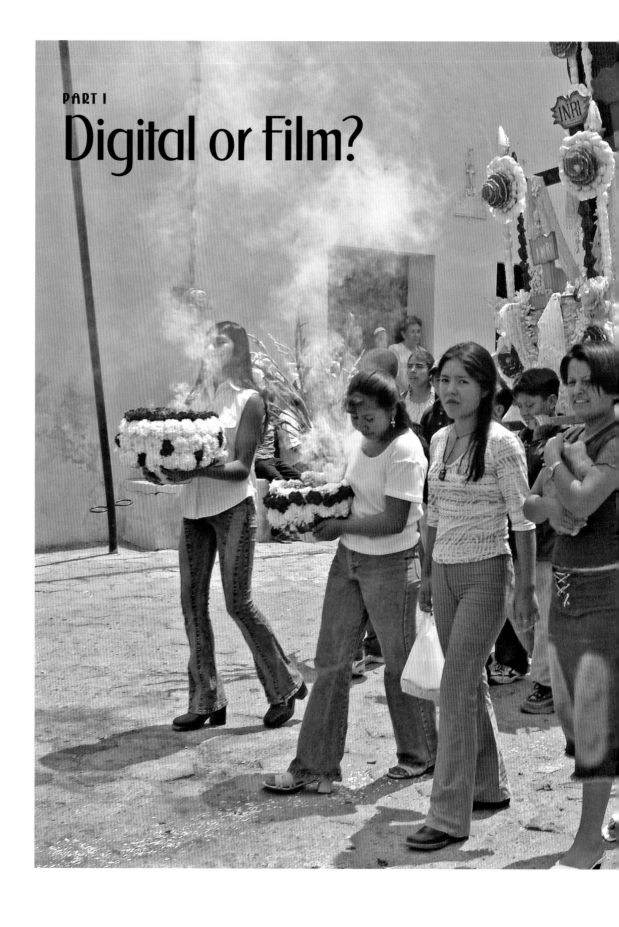

Digital or Film?

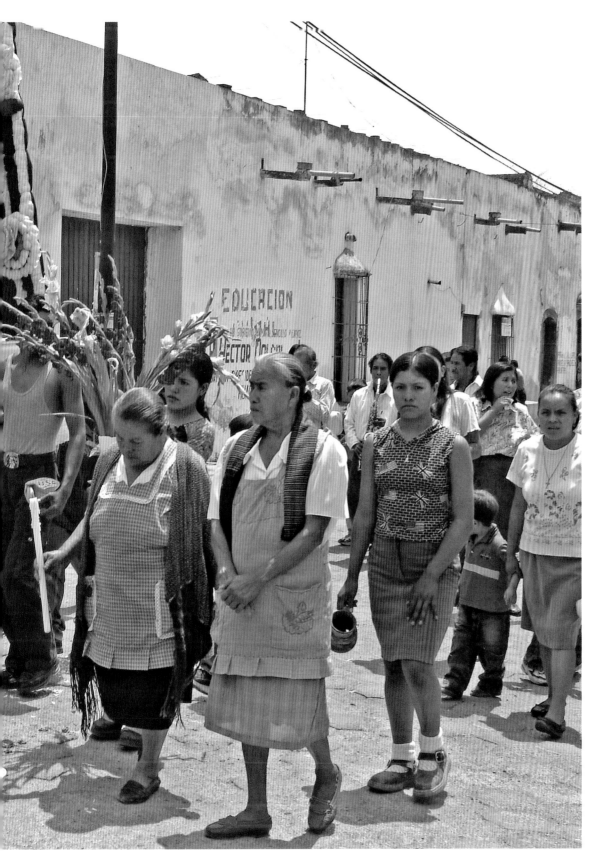

Village saint's day parade, near Puebla, Mexico. Here, it helped to have inside information. My driver in Mexico, John O'Leary, helped me find this early-May celebration, where I was the only tourist. 28mm lens, 100 ISO digital setting. The misty sunlight was not too harsh, even at noon, when I had to make the shot. Exposure was 1/250 at f/8.

Overview of Formats

If you are acquiring equipment for serious travel photography, or will do so soon, you have some decisions to make about your medium. Will you shoot digitally, or will you use film? If you shoot film, will you make fine-art prints in your darkroom, or later scan the film images into a digital file for easy retouching and printing?

High-quality digital capture from a camera that generates un-retouched original files of at least 4 or 5 megabytes and up is now acceptable to many commercial and stock photography clients. Though some say digital capture will be the norm for all but a handful of fine-art photographers in a few years, I think that film, which can be so beautiful, is here to stay. As for output, whether a picture is an original digital capture or recorded on film truly doesn't matter. The quality of the photograph is what counts.

For many years, I made prints in a traditional darkroom. Now, my darkroom is digital, and it is enormous fun to be able to quickly retouch and "tweak" images, and make prints, enlargements, greeting cards, calendars, announcements, and portfolio pieces and more in daylight. Digital files can be "interpolated" with special software for printing large blow-ups. I have a relatively inexpensive digital darkroom and am very happy with my print output. And now, even some high-end New York photo galleries are exhibiting and selling digital prints.

Here is a summary of the advantages and disadvantages of shooting film versus digital when you travel, based both on my own experience and on questions put to other photographers, art directors, and stock picture agencies.

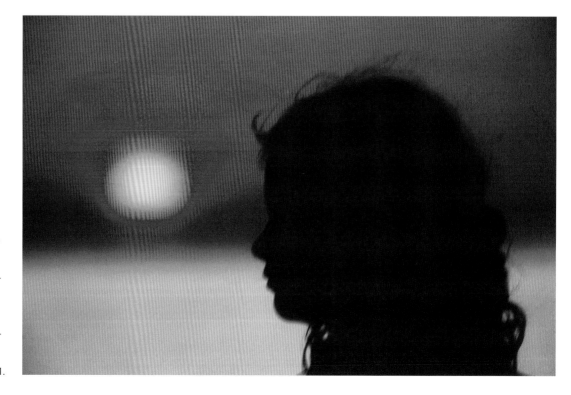

Silhouette of my daughter Caroline at sunset, Cape Cod, Massachusetts. An f/100 camera, 100 ISO film, and an 80–200mm lens were used, hand-held. To get the black foreground effect, I metered close to the sun itself. Several bracketed exposure variations were made, based on 1/250 at f/11.

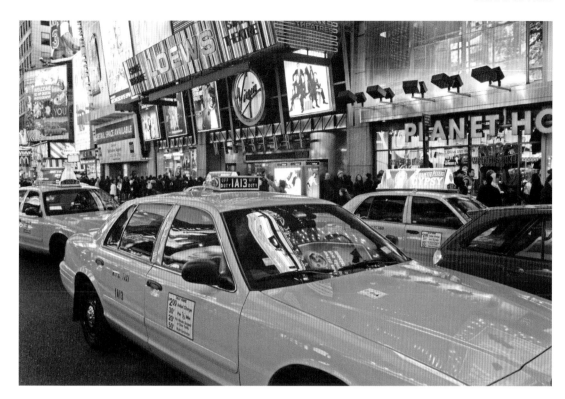

Times Square taxis, New York. S-2 Fuji digital camera, 20mm lens, 800 ISO setting. Exposure was 1/20 at f/4, handheld.

In April 2004, the *Queen Mary II* completed her maiden transatlantic voyage and berthed next to the *Queen Elizabeth II*, which was about to make her last such crossing, at New York City's cruise ship terminal. I shot them from Weehawken, New Jersey, with a Fuji S-2 and 70–300mm f/4–5.6 Nikkor lens mounted on a tripod. Exposure at 100 ISO was 1/500 at f/5.6.

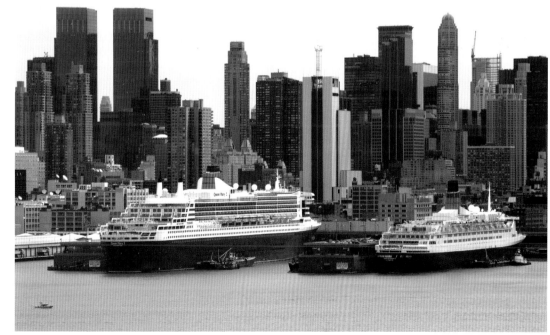

The Pros and Cons of Shooting Digitally

1. For me (I shoot for many self-assigned and long-term personal projects as well as for assignments), the greatest advantage of digital photography—a.k.a. "digital imaging" or "digital capture"—is that I can experiment and take any photographic risks I want without worrying about film costs. This allows me the same creative freedom I had when starting out in the 1960s. At that time, clients paid for everything without question, and I considered the cost of a roll of film to be as unimportant as the cost of a roll of toilet paper.

2. The next advantage of digital photography is that to the best of my knowledge and that of several digital gurus I know, the various types of "digital media"—the tiny Smart Cards, Memory Sticks, Microdrives, etc., that record digital images—are not affected by the x-ray machines used at airports to scan carry-on luggage. I have a sturdy regulation carry-on-size photographic bag to hold my digital gear. I pack cameras, lenses, media cards, laptop, flash, and more into this and put it through the scanner. The laptop must always be removed and scanned separately, so make sure your laptop is easy to get at. I never, ever put any digital media or film, or fragile, valuable, or irreplaceable gear into my checked luggage.

3. A very big advantage of shooting digitally is that you can immediately see what you've got, though it's sometimes hard to judge exposure exactly by looking at an LCD screen. If you rely on constant checking of your images this way, carry plenty of rechargeable batteries or, even better, rechargeable battery packs with you because any lit LCD screen is a heavy drain on battery power.

4. With an adjustable digital camera, you can alter the ISO speed set on the camera anytime you like—no need to get to the end of a roll to switch. My Fuji S-2 Pro camera permits switching from 100 ISO while I'm shooting flash, up to 400, 800, and 1,600 ISO, when the light changes or I want moody, available-light pictures indoors. (ISO stands for International Standards Organization, and is a measure of a film or digital medium's sensitivity to light. The higher the ISO number, the more sensitive the medium.)

5. And yes, after you've invested between a few hundred to a few thousand dollars in one or more user-adjustable digital cameras, perhaps some special lenses, battery packs, chargers, digital media cards, a laptop with a disc burner, and more, you are home-free financially.

Having shot film for about forty years, to keep up with the times I bought my first digital camera about two years ago, and now love digital capture and shoot with digital equipment unless asked to shoot film by a client. About 25 percent of the pictures in this book are digital originals (see the captions to identify them).

For amateur photographers there are few downsides to digital. The main one is that inexpensive basic and intermediate one-piece cameras are slow or somewhat slow to focus and fire, and may cause you to miss fleeting moments. Learn how to pre-focus and hold focus to minimize but not eliminate this delay (see camera manuals). Serious one-piece "prosumer" cameras (a name coined for models popular with both professionals and consumers) focus reasonably fast and have come down in price recently. For the latest information see photo magazines, research via the Web, and handle several cameras before making a final choice. Inexpensive digital processing is now offered almost everywhere at mini-labs and big chain stores like Walgreens and Wal-Mart.

The downsides of digital for professional and would-be professional travel photographers are:

1. The initial cost of high-quality, high-resolution digital cameras plus necessary accessories is still higher than that of comparable film cameras, though well-priced interchangeable lens digital SLR cameras are now available. You will probably need to buy an image storage device or laptop computer if you travel for extended periods.

2. The time you must invest to learn the skills needed to program the camera and process digital images on the computer is considerable; it took me a couple of months before I felt truly at home shooting digitally. But I practiced, and now it's second nature.

3. At first especially, there is a real risk of accidentally deleting important images. Until you are quite expert, be sure to work slowly, and backup everything at every stage.

4. Time must be budgeted each day when on the road to download images from the camera to the computer and then to burn backup images onto writable CD-ROM discs.

5. With all electronic and digital equipment you must have access to a/c power every day or so to recharge camera, flash, and laptop batteries. Many countries overseas use different voltage than the United States and in those places you will need to carry appropriate electric plug adaptors and possibly a step-down voltage transformer. (See page 147.)

6. Finally, there is still some resistance to digital images from high-end photography users and printers. Some art directors, editors, and printers for top magazine and book publishers are not yet too receptive to using digital images. But this is changing everyday, and those skilled with high-end equipment are swiftly overcoming lingering prejudices.

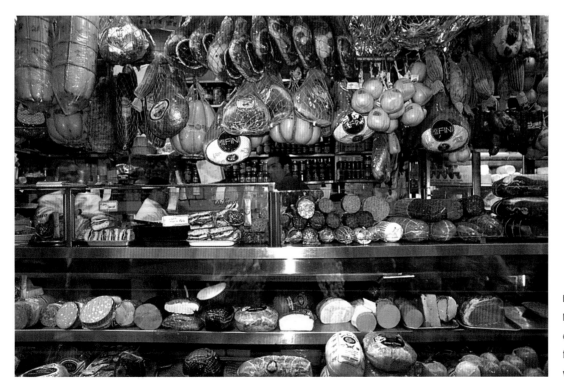

Delicatessen interior, the Bronx, New York. S-1 Pro digital camera, 400 ISO setting, plus fill from pop-up flash. Exposure was 1/30 at f/4.

The Pros and Cons of Shooting Film

1. Excellent user-controllable new and used film cameras and lenses are available in all formats, many at bargain prices. Film is familiar and acceptable to most commercial printers and color separators.

2. New films are still being introduced; film is not going to disappear anytime soon. Ellis Vener, an Atlanta-based photojournalist, says this is a great time for film shooters. Competition from digital has forced improvements in many professional and amateur films. Fuji's Velvia, for instance, great for travel, nature, and landscape work, is now rated at 100 ISO, up from the original 50 ISO, permitting higher shutter speeds or smaller apertures. Fuji's improved Astia, formerly 50, now 100 ISO, is excellent for natural-looking skin tones. Agfa's beautiful Scala black-and-white slide film can now be processed at 100, 200, or 400 ISO. Eastman Kodak has not been sleeping either. Kodak's Ektachrome G and GX films (that replace S and SW emulsions) are becoming favorites of portrait, fashion, and beauty photographers who need truly natural skin tones for editorial, advertising, and commercial uses. Kodak's new Ektachrome VS slide film has warm tones, great for many travel subjects, and a new Ektachrome 200 can be "pushed" (ISO speed increased) by professional labs, to 400, 640, or 800. In my opinion, Ektachrome 400 film is still unsurpassed for work in low light and especially for holding blues at twilight and giving true blacks at night.

 Kodak's Portra negative films come in speeds from 100 to 800 ISO and have wonderful skin tones for those who need traditional color prints, small or large. And Ilford and Agfa as well as Kodak and Fuji have fine black-and-white negative films in different speeds and film formats too. I still like Kodak's T-Max-100 and Tri-X (400 ISO) films when shooting black-and-white negatives.

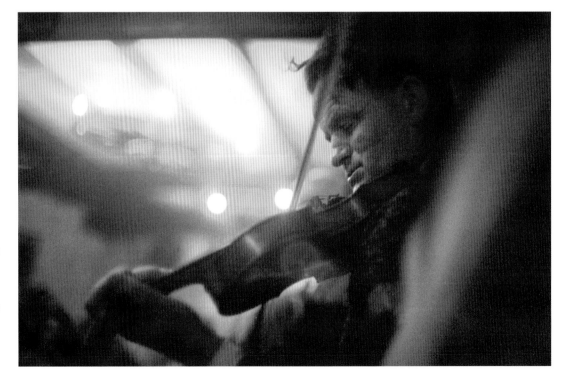

Fiddler in pub, Dublin, Ireland. With daylight-balanced 200 ISO film and a 50mm f/2.8 lens, handheld. I enjoyed the music while working my way as close as possible to the fiddler, shooting quite a few images. Exposure was 1/30 at f/2.8.

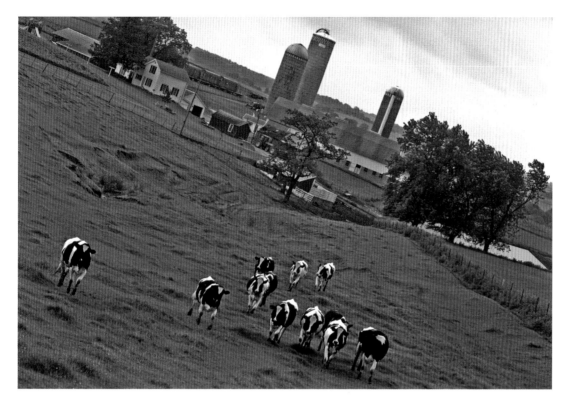

Wisconsin farm. I was in the Midwest as part of a trip to fill in my geographic coverage of the fifty states. I was admiring this prosperous farm when the cows came to investigate me. Exposure with 100 ISO film was 1/125 at f/5.6.

Whenever I'm shooting film, I carry one slow fine-grain film and one fast film. In addition to the films noted above, all manufacturers make amateur emulsions that will give excellent results, and they offer information on all current film choices on their Web sites (see Resources).

If you shoot film all or most of the time and don't process and print the images yourself, establish a relationship with a good professional film lab—this is especially important if you shoot professional color slide films. Lab quality does vary considerably, and although poorly processed images can be saved today by scanning them into a retouching program like Adobe's Photoshop, this demands time, skill, and work.

The main arguments *against* shooting film are:

1. Film and processing are expensive if you are paying lab costs yourself, though major publications, but *not* most stock agencies, do cover film and processing expenses for assigned work.
2. Security measures now necessary at airports worldwide mean that one must always worry about the effect of cumulative x-ray screenings on film. *Always* carry film with you in your carry-on luggage. *Never, ever* put film of any kind in checked baggage. The new high-powered machines that now screen checked bags will ruin films. (A couple of passes through the scanners used for hand luggage will not harm slow- and medium-speed films.) Always protect high-speed film in Sima lead bags, available at photo dealers, if you travel with any high-speed films or must pass through several airports on one trip.

Tools for Travel Photographers

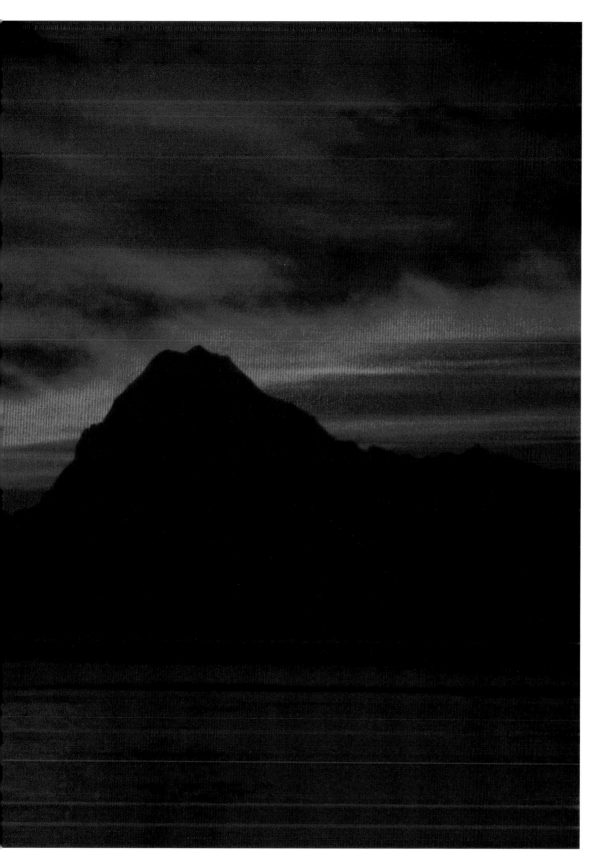

For the red sunset of Moorea, I used 1600 ISO film, a 70–300 mm lens, and the camera was handheld. I metered off the sky and bracketed (varied) the exposures by 1/2 stop over and under normal.

Camera Overview

If you are making an extended trip to a remote place or one with extremely harsh conditions, seriously consider traveling with one or more high-quality, all-mechanical film cameras—a model with a built-in exposure meter dependent on a small battery is OK, but carry a spare meter. Electronic film and digital equipment is essentially run by mini-computers. Rain, dust, sand, salt water, great heat, or extreme cold can all cause problems where you may be far from repair services. On trips to places where repair services will be available, select appropriate film or digital cameras and lenses from amongst those you own. All but the inexperienced should opt for user-controllable equipment, not program-only point-and-shoot cameras, though these can be carried as backup. When choosing lenses, remember that a hotel shoot would call for different lens choices than a safari. Choose accessories carefully; a lightweight but sturdy tripod is a must, as are one or more battery packs and chargers if you shoot digitally and/or use flash extensively. Test everything to be sure it's in good working order. If you acquire any new gear before a trip, get thoroughly familiar with it before you leave. Finally, I never, ever travel anywhere without a backup camera. Ideally, this should be identical to the main camera so that fumbling with unfamiliar controls does not cause missed peak moments.

35mm Single Lens Reflex Cameras

The majority of travel photographers use the 35mm SLR (single lens reflex) format or its digital equivalent, the reasons being the relatively light weight of the equipment and the huge choice of lenses and accessories available. Electronic cameras should offer the choice of Program (P) mode, plus Aperture Priority (A or AV) mode—this allows you to control depth-of-field. The camera should also permit shooting in Shutter Priority (S or TV) mode—this permits you to control motion and blur effects and to vary long exposures. Manual (M) mode permits you to control both aperture and shutter speed, permitting variations from "normal" for artistic purposes. I shoot in this mode all the time. Finally, a camera with a Stop Down Preview button is essential for me. This permits previewing depth of field—the zone of sharp focus—essential for still lifes and more (however, this option is not available on most budget SLR cameras).

When buying equipment, search the Web for up-to-date camera model numbers and specifications, and/or check out a buying guide from *Shutterbug*, *Digital Imaging*, and other photo magazines. I also recommend going to a good camera store and handling equipment. A camera can be great, but too heavy for a woman (I do not like the Nikon F5 for that reason) or too small to fit comfortably in a big man's hands, for instance. A tripod may look good on paper, but shake slightly when in actual use.

Film Cameras

The top 35mm film SLR brands are Canon, Contax, Nikon, and Leica. Canon and Nikon especially offer a range of budget to high-end pro cameras. A great many professionals I know swear by their pro Canons, and I wouldn't argue that Canon autofocus is faster than anyone else's.

My camera system choice is Nikon. I currently own a Nikon F-100, a wonderful camera, plus an old manual FM-2 (replaced by the FM3N) that has given me years of faithful service, and an even older Nikonos V underwater camera. Recently I have gone mostly digital, and own two Nikon-

body–based Fuji digital cameras (see below). In the past I have owned N-90 and N-90S and F2 and F3 Nikon models, all excellent and all still available used.

Konica Minolta and Olympus make fine equipment, considered to be only a notch below the above brands. Many students of mine have favored Pentax over the years; their manual cameras in particular have long been photo-school workhorses. Sigma makes good budget 35mm SLR cameras and lenses that fit its own and other cameras too. And Leica makes both SLR cameras and legendary rangefinder cameras.

Digital Camera Overview

It is my opinion that digital SLR cameras with sensors that match or are close to the size of the 24 × 36mm format used by 35mm film cameras, and with interchangeable lenses, are currently the cameras offering the best value and options for serious and professional travel photographers. The images they can capture are detailed enough to be acceptable to most publications. Most such digital models are similar in size and weight to high-end professional SLRs, and the same lenses and accessories that fit film versions of these are available for them. At the time of writing, the few digital cameras in this category can "capture" (record) 11 or 14 megapixels of data, producing photographs that rival the image quality of film at an equivalent ISO. Less expensive SLRs capture a 5 or 6 megabyte file onto a sensor that is about 80 percent of the area of the 35mm film format.

I will not be specific as to most digital camera model numbers except for my own current cameras and a few others that I know a lot about. I currently have a 6 megabyte Fuji-S2 Pro model based on the Nikon N-80 camera body. I paid $2,000 for it without lenses. The S-2 gives great color, and it can fire a burst of five shots continuously, a speed of operation that is plenty fast enough for me. If I had a wish for this model, it would be for larger markings and a slightly more rugged "feel." My first digital camera was a 3 megabyte Fuji S-1 based on the Nikon N-60 body. It too is fast-operating, gives great color, and is easy to use. I now use the S-1 as my backup. You should be able to find a clean used one around for about $700 today. Both the S-2 and S-1 models accept most autofocus Nikon lenses and lenses with modular Nikon mounts and most Nikon accessories. See picture captions to identify shots made with both of these digital cameras throughout this book.

The Digital Magnification Factor *by Joe Farace*

One of the most noticeable differences between film-based cameras and the new breed of digital SLRs is the so-called magnification factor. Other than the Canon EOS 1Ds and Kodak DCS Pro 14n, all of these cameras have imaging chips that are noticeably smaller than the 24 × 36mm format used by 35mm cameras. That difference shows up in a magnification factor or ratio that turns a 50mm "normal" lens into something longer. How much depends on the camera. The Nikon D1H, D1X, and D100 have a factor of 1.5. The Canon EOS 1D has a factor of 1.3, while the EOS D60 and 10D is 1.6. This means a 50mm lens on my D60 shows the equivalent area of a 80mm lens, but it's important to realize that I haven't attached a teleconverter—the focal length of the lens remains the same. The difference in the viewfinder is that the image looks like a 50mm shot that was cropped into the angle-of-view of an 80mm lens. If you're a wildlife photographer salivating at the prospect of turning your 400mm lens into a 640mm, keep in mind that your subject is still going to be the same size, just cropped tighter. My favorite lens for available-light fashion indoors is the 85mm f/1.8,

SOME RECOMMENDED CAMERAS

Bear in mind that you can use any digital or film camera you are already comfortable using to begin making serious travel pictures; it's the intent, not the equipment, that is important. If you are looking for a few digital camera recommendations, here are my current choices. Most have interchangeable lenses, and all have fully user-adjustable settings plus program controls. If you like to shoot film, there are so many good 35mm SLR camera choices that I can't show them all here.

❶ The highly regarded 14mb Canon EOS-1 Ds digital single lens reflex camera has a sensor that covers the same area as 35mm SLR film cameras (when using the same focal length lenses). It is the camera of choice for many top digital photographers.

❷ The Kodak DCS Pro, a high-end 14mb camera with about the same lens coverage as that of 35mm SLR film cameras; a recent price drop has made it an attractive buy for Nikon lens users. This camera is currently the only digital camera that can be upgraded with new "firmware."

❸ The Nikon D2H, an upper-mid-price 4mb SLR digital camera is designed for ultra-high-speed shooting. It is especially good for photojournalism, sports, and wildlife photography, and for any fast-moving subjects and events. Lens coverage is about 80 percent of that of 35mm SLR film cameras, so you may want to buy a super-wide-angle lens if you like to make many wide-angle photographs, as I do. Nikon also has several other SLR and one-piece digital choices.

❹ The Canon Digital Rebel is a moderately priced 6mb digital SLR camera that accepts most Canon interchangeable lenses. Lens area of coverage is about 80 percent of equivalent film cameras.

❺ The Canon PowerShot S-50 is a one piece, cigarette-pack-size 5mb digital model that is my choice as a backup camera. It has a sharp 4× f/2.8–f/3.9 zoom lens that retracts so that the camera can slip into a pocket, a tiny flash, and program- plus full user-control options. It comes in handy as an emergency backup, and also when I prefer to look like a simple tourist, not a professional photographer. An optional underwater housing makes the camera useful for casual shooting in, on, or near water and in wet weather.

❻ A well-traveled amateur-photographer friend who no longer wants to carry heavy equipment just bought this 5mb Canon PowerShot G-5 one-piece model. It has a built-in fast f/2–f/3 4x zoom macro lens that focuses as close as four inches, which is great for her special interest in flower photography. It has program and user-adjustable controls, plus a built-in flash. Rare in point-and-shoots, optional telephoto and wide-angle lens adapters and a detachable flash are also available.

❼ I currently use the Fuji S-2 Pro as my main digital camera; it is a mid-price 6mb interchangeable SLR that is compatible with most Nikon lenses and accessories. On this camera, a 14mm Nikon lens gives about the same coverage as a 20mm lens on my 35mm Nikon SLR film cameras. Many of the pictures in this book were shot with the S-2 Pro. (Note that digital camera models change frequently; I may be shooting with the S-3 by the time you read this book. Check camera dealers for updates.)

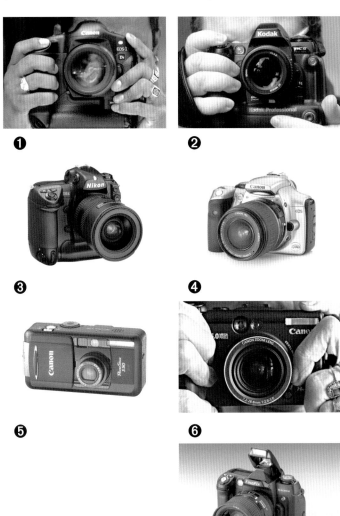

❶ ❷

❸ ❹

❺ ❻

❼

but in order to keep the perspective the same, I've got to back up to fill the frame the way I do with my EOS 1N film camera.

One-Piece Digital Cameras

If you prefer to carry a lightweight, inconspicuous camera when you travel, need a backup, don't need big enlargements, want to look like a tourist rather than a professional photographer, or just have a tight budget, consider a good one-piece digital camera. Some have a fixed, moderately wide-angle lens plus a tiny flash and will fit into a shirt pocket. Others are actually digital SLRs, but with fixed, non-interchangeable zoom lenses that some pundits have taken to calling "ZLRs" (zoom lens reflexes). Moderate-price digital camera options can include General, Landscape, Macro, Portrait, Sport, and Night modes. On advanced models, you may get Program, Aperture Priority, Shutter Priority, Night Portrait (or a similarly named mode), Macro mode, and even full Manual mode too. The price range for good one-piece digital cameras is about $400 to $1,500 at present. Do be aware that almost all of these cameras have smaller sensors than most 35mm-size digital cameras, so you can't make as big enlargements (see box on the bottom of this page for more information). The images they capture are great for album-size up to about 8" × 10" prints, for e-mailing, and even for display on professional Web sites.

Canon, Contax, Konica Minolta, Leica, Olympus, Nikon, Pentax, and Sony all make good one-piece digital cameras. My two current choices are shown in the photos. Most one-piece digital cameras capture relatively small files that can easily be downloaded from whatever type of "media card" your camera uses to almost any computer. After downloading, you can retouch or manipulate digital images and make digital prints via a photo manipulation program, and "burn" original and retouched digital pictures to CD-ROM discs for permanent storage. If you prefer, a service bureau or one-hour photo store or even your local Wal-Mart can save your images permanently to disc, and make prints and enlargements. Digital service bureaus can even make a slide show for you.

Finalizing Equipment Choices

Because of the sheer numbers of small-size and 35mm-size film and digital camera models now available, you must rely on the latest amateur and professional photo magazine buying guides and manufacturers' Web sites for up-to-the-minute camera model numbers, features, and price comparisons. Fine art and landscape photographers who travel may wish to use a medium- or large-format camera, and almost all models accept digital backs. Such equipment can produce enlargements with extremely fine detail, but is essentially outside the scope of this book. However, I do know this: Mamiya and Hasselblad make the most popular medium-format cameras; digital backs are available for both, with more digital backs available for Hasselblad models than any other manufacturer.

Why Digital File Sizes Matter

The critical issue if you want to shoot digitally for publication in books and magazines, and/or for possible stock sales—or if you plan to make big enlargements for exhibition—is the "file size" you can "capture" with a given digital camera. Not surprisingly, the bigger the camera or camera back, the bigger the sensor and the file size that can be captured.

Professional and near-professional cameras are often rated in "megabytes" but sometimes in "megapixels"—both refer to the file size they can capture. The popular one-piece digital cameras with built-in zoom lenses and the slimmest "point-and-shoot" models are usually rated in megapixels, and some camera makers claim "interpolated" (this means pixels are added by the camera's software) or "equivalent" digital file sizes for marketing purposes. All this can be confusing.

Most one-piece and point-and-shoot digital cameras have smaller sensors than current popular 35mm digital SLR cameras, with lens interchangeability. Medium-format and large-format digital cameras and digital backs have bigger sensors than 35mm digital camera sensors. Therefore, the files from each type of digital camera produce different-quality images when enlarged to the same size.

Currently, a camera that can produce an uninterpolated 18 megabyte TIFF file—the minimum file size acceptable to many publishers and stock picture agencies—is what to buy if you hope or intend to publish digital images. Such a camera will currently cost you from around $1,000 and up—without lenses or accessories.

(Note: "TIFF" means Tagged Image File Format. For much more on digital terminology and to get comfortable with "computerese," I highly recommend reading *The Digital Imaging Dictionary*, by Joe Farace.)

Lens Overview

Essential for any travel photographer is the capacity to record wide landscapes and large and small interiors, bring distant people and scenes close up, and, sometimes, fill a camera frame with small subjects and objects. Therefore, you will need three good lenses at minimum to cover most travel situations. Your wide-angle choice could be a 14mm super-wide-angle, or a compact 20mm or 28mm lens, or even a wide-angle zoom lens—most have a range of 20 to 35mm. A telephoto zoom lens that extends from 70 or 80mm to 200 or 300mm is extremely useful—the one I carry most often is a relatively inexpensive and lightweight Nikkor f/4–f/5.6 70–300mm zoom. I also own a Sigma 80–200mm f/2.8 zoom—it's fast, sharp, and heavy. I use both zooms for wildlife, sports, bringing mountains close, and sometimes for making frame-filling portraits too.

In addition to my long lenses, I often carry a "tele-extender" or two. These are modest-size devices, about the size of a 50mm lens, which increase lens focal length. I have a 1.4× extender, and a 2× extender. Both are automatic and work with both my digital and film cameras. The 1.4× extender increases focal length by a factor of 1.4, but reduces the lens aperture by one f/stop. The 2× extender doubles the lens focal length, but reduces lens aperture by two full f/stops, so I find them most practical only with my fastest long lenses.

My third basic lens choice is a fast or super-fast f/1.4, f/1.8, or f/2 aperture 35mm, 50mm, or 80mm lens with "macro" (close-up) capacity. I own both the 50 and 80mm focal lengths, and use them indoors for available light portraits, outdoors at night, and for nature and other close-ups too.

A point-and-shoot camera with a lens that zooms from the widest available angle to moderate telephoto—a 35–105mm lens, for instance—and also has some creative controls and the macro mode, is a good choice if you are just starting to shoot travel pictures, as well as for a backup camera. My suggestion would be to check out some current Canon and Nikon models.

The Most Useful Lenses for Digital Cameras

At the time of writing, lenses specifically designed for certain digital SLR cameras are just coming onto the market, notably made by Olympus and Nikon. The big advantage of such lenses will be that they are designed to cover the digital-camera format; a 20mm lens will be a true 20mm, and so on, but, they won't be good on your film cameras. I have not tested out one of these lenses yet.

Again, with digital capture, get the fastest lenses you can afford, provided you can carry them! Many lenses designed for film cameras also fit current digital cameras. The fact to remember about these lenses is that at this time, almost all digital cameras multiply the lens effect by a factor of approximately 1.4–1.6.

The Most Useful Lenses for Film Cameras

Conventional wisdom is to get the fastest lenses you can afford, but bear in mind that fast telephoto lenses especially can be heavy as well as expensive and that sometimes cheaper, lightweight tele and zoom lenses do the job just fine. I like f/2.8 or faster normal and wide-angle lenses. I will not buy any fixed lens slower than f/4, or any zoom lens slower than f/4–5.6. The slow shutter speeds they often require can cause blurred action shots even if used with high digital ISO settings or high ISO film, or a tripod, or both.

It's Not the Camera, It's the Photographer

I use Nikon SLR film cameras and Nikon-body-based Fuji digital SLR cameras, and own some lenses and accessories that fit them. I am very comfortable with my equipment, but don't get paid for any of my recommendations. Be assured that the film and digital camera and lens facts and suggestions apply equally well to Canons, Contaxes, Konica Minoltas, Leicas, Pentaxes, and some other brands too. Contact manufacturers (see Resources) to learn more about your own favorite brands of cameras, lenses, and accessories. And remember that it's the photographer's "eye" and skill and not the brand of equipment used that makes for great pictures. The initiated can recognize major photographers' styles; one can say "that's a great Ansel Adams landscape" or "what an hysterically funny Martin Parr tourist picture," but I have never heard anybody say "that's a great Hasselblad shot," or "look at how well the Nikon 80mm lens composed that Eiffel Tower view."

The Most Important Accessories for Film and Digital Shoots

Whether you are a seasoned travel photographer or setting out on a first major trip, three items—the tripod, collapsible reflector, and the adjustable flash unit—will enable you to make pictures that would be difficult to impossible without them.

The Invaluable Tripod

A decent tripod is my favorite accessory and I never travel without one. I use my tripods (I own three) for composing still lifes, location portraits, and group shots, and for preventing camera shake for time

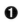

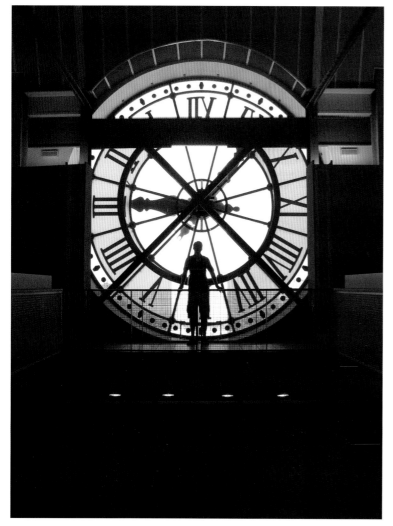

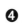

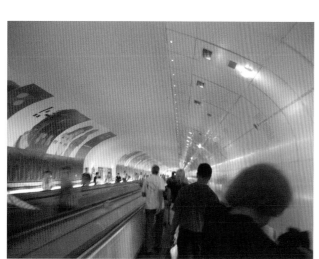

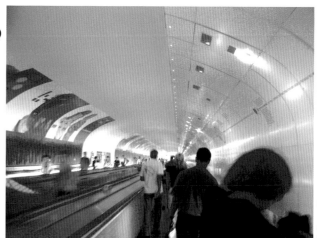

POINT-AND-SHOOT TRAVEL PICTURES

The four images on the opposite page were taken by a young friend, Kerynn Fisher, with her Canon S-45 4-megapixel camera on a whirlwind three-day trip to London and Paris in June 2003. Kerynn has absorbed much from her photographer parents, my good friends Pat and Wayne Fisher, though she claims to be a strictly amateur photographer.

❶ Clock, Museé d'Orsay interior, Paris, France. This image is lit mostly by daylight, has excellent color, and is reproduced here unretouched. Kerynn says that she shot in Program mode and used the lens at its widest angle setting.

❺

❻

❷ Guards leaving Buckingham Palace, London, U.K. Kerynn says she shot in Program mode with the S-45's built-in zoom lens at its telephoto setting, and that the result was not so much about her photo skills as about her ability to quickly wiggle through a big crowd to reach this unobstructed viewing spot. This image has not been retouched.

❸ Metro interchange, Paris, France. Kerynn grabbed this shot on a moving underground walkway with her camera set to Program mode. Blur was caused by the program needing to set a slow shutter speed, but that blur contributes to the bustling mood of the scene.

❹ "Tweaked" shot of Metro interchange, Paris, France. It's possible with Adobe's Photoshop and other image manipulation programs to improve digital images as well as pictures scanned to a CD from film. You can correct or alter color and contrast, increase sharpness, retouch imperfections, remove unwanted elements, and more. Here, I took out as much green cast as possible and sharpened the image.

❺ Using my Canon S-60 point-and-shoot, I snapped this painter in Central Park in New York City using Program mode. I later cropped the image slightly and tweaked the color using Photoshop.

❻ I captured this butterfly with my Canon S-60 5-megapixel point-and-shoot camera, which was used in Program mode with the close-up setting (a flower emblem) activated. Afterward, I cropped it slightly using Photoshop.

The New York skyline from the top deck of the original *Queen Elizabeth*. This shot proves that evocative travel pictures are possible with any camera! I made it with a plastic Ansco twin lens reflex at about the same time that I got my first glimpse of America in the 1950s. For this book, I scanned the original two-by-two-inch drugstore print, which had discolored slightly.

exposures in low light or at night. They are a necessity when shooting wildlife with long, heavy tele-photo lenses to prevent blur caused by lens shake. I don't shoot sports often, but they too are some-times part of travel coverage and also require the longest lenses. While professional sports photogra-phers favor single-leg "monopods" to support long lenses in daylight, a tripod becomes an effective monopod when the legs are pushed together. A tripod is an absolute necessity for leveling cameras when shooting architecture and interiors with wide-angle lenses—you must level these lenses extremely carefully, or you will get distortion, converging lines, or crooked-seeming walls, floors, or ceilings.

For comfort for any but the most casual use, any tripod with a camera mounted on top should be tall enough to enable you to stand straight with the viewfinder at eye level. Good tripods have detachable heads, and different types of heads are available. I favor easy-to-level "ball" heads with a quick-release device on top. These require an appropriate quick-release plate mounted below the cam-era, via the tripod bushing, making it easy to mount cameras in the dark. I highly recommend both top-of-the-line French-made Gitzo and budget Italian-made Manfrotto brand tripods; both come in many sizes, have several head and quick-release options, and both are well-made and repairable with

excellent U.S. service. Caution: Inexpensive tripods designed for amateur video cameras are not sturdy enough to support heavy lenses, and can only be leveled forward and back, not from side to side.

Collapsible Fabric Reflectors

These lightweight, handy devices are a big lighting secret, unknown to many inexperienced photographers. They pack up small and can be aimed by you or a traveling companion, or taped to a tripod or light stand and angled so they "bounce" or reflect sunlight (or a photo light) back into close shadowed areas of a composition. This reduces contrast between highlights and darkest areas—reducing contrast is especially important for digital photography because overexposed areas of a digital picture are often "blown out"—and stark white areas of digital images are usually beyond hope of rescue even with the help of Adobe's famous Photoshop photo manipulation program.

Round, fabric light reflectors spring open to sizes ranging from 12" to 48" or more, with white, silver, or gold finishes (for soft, harder, and warm-toned reflections) and are made by several companies. I can hold and aim a 36" round reflector with one hand while shooting with the other even if my camera is not motorized or on a tripod. I favor sturdy Photoflex reflectors that are stable even in a breeze, and I like a white and silver combination.

Detachable, Adjustable Flash Units

If your camera accepts a detachable flash unit—almost all moderate-price and high-end film and digital cameras made today do—you can achieve sophisticated lighting effects with units about the size of two joined cigarette packs. Effects can include "flash fill" of close shadowed areas in bright sunlight, and both frozen motion and blur in the same shot with the Slow Sync flash technique. Slow Sync is a combination of a high-speed motion-stopping flash burst and a slow shutter speed. The flash "stops" or freezes the motion of nearby subjects silhouetted against dark backgrounds, while the slow shutter speed permits recording low-lit moving subjects or objects beyond flash range. Flash also permits emphasizing foreground subjects against slightly underexposed distant views in poor weather and low daylight or—with camera on tripod—combining flash with a long time exposure at night.

Get a flash with a head that angles, so you can "bounce" softened light onto people and groups and avoid most red-eye. Use the tiny white reflector card built into some adjustable flashes, or better, place a light softening device over the flash head. I like both the LumiQuest pocket bounce and the Sto-fen dome devices. Top flashes may have heads that rotate as well as angle up, so you can bounce light off a nearby white wall or collapsible reflector. If you have a film or digital TTL (through-the-lens metering) camera, by all means get a compatible through-the-lens metering flash. You are always safe getting one marketed by your camera manufacturer; some advanced models have cords permitting TTL metered use off camera.

Three respected companies market modular flashes, in different price ranges. Metz, Quantum, and Sunpak modular TTL flash units fitted with the correct adapter will fit most camera brands. Expect to pay between about $80 and $600 for any good TTL flash, depending on design, power, and features.

The Quantum Q-flash, with several round reflector options and the possibility of "bare-bulb" use, is my choice of top-of-the-line modular, battery-pack-powered TTL flash unit. If you have a mechanical

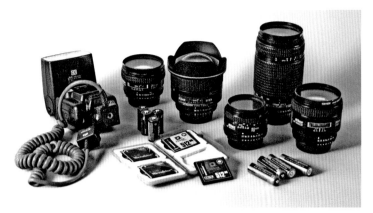

Some of my digital accessories, clockwise from left: Nikon SB-26 Through the Lens Metering flash (TTL) and SC-17 cord that permits using flash in TTL mode off camera, 20mm f/2.8 lens; 14mm f/2.8 lens; 70–300mm f/4-5.6 zoom lens; 80mm f/1.8 and 50mm f/1.4 lenses; rechargeable NIMH batteries that fit both camera and flash; lithium batteries needed for the S-2 and digital media. I use fast 512mb Lexar brand Smart Cards and 1gb IBM Microdrives. When shooting digitally on the road, I also carry a laptop computer to download images from cards and burn them to CDs (not shown).

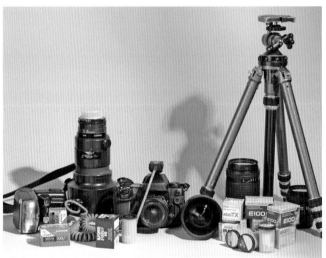

When shooting film, I carry the Nikon F-100 camera, a TTL flash and cord, and the lenses that also fit my digital camera. These include the 300mm Tamron f/2.8 lens shown. I love using this for wildlife photography. Also shown are my favorite Gitzo Reporter tripod with a Gitzo ball head, plus the Kodak, Fuji, and Ilford films I like.

camera, get an inexpensive Vivitar 283 or Sunpak automatic-flash unit (not to be confused with tiny cameras' built-in auto flashes or the TTL Auto Flash mode). The price will be under $100.

Bags and Cases

If your travels are by car, just about any lockable, sturdy luggage will do—in fact, the less it looks like photo gear the better. One bag for extremely valuable and/or fragile items that will never leave your hand or side should be airline carry-on size, normally 9" × 14" × 22", but check with your airline. Such bags are always handy; good non-photographic ones can be had for under $100, and you can always pad fragile photo items with clothes.

For travel by air, train, or bus, choose at least one bag designed to protect cameras, with padded dividers that you can customize; there are a number of good brands. I own two Tenba backpacks of different sizes plus a Tenba padded tripod light-stand bag and a small, inconspicuous shoulder bag, as well as a padded Lightware case for whatever portable lighting I must carry. These take care of cameras, film or discs, accessories, and flash units. For my digital or film shooting gear, I most often use a Tamrac Big Wheels carry-on size rolling case that takes two 25mm SLR film or digital cameras plus laptop computer, discs or film, and accessories.

I always keep everything but my "shooting in the street" shoulder bag padlocked—I even padlock backpack compartments to protect against pickpockets. Having the padlocks identically keyed is a timesaver.

Image Storage

If you're shooting digitally, sooner or later you will need to store a fair number of images and free up your media storage cards so you can capture new pictures. There are basically two bulk storage choices for digital imagers.

The first and best in my opinion is to carry a laptop computer that incorporates a CD-ROM or DVD disc burner. That way, you download your digital images from the cards to the laptop (I use an inexpensive Lexar digital "card reader" for this) then you can "burn" (make a permanent copy of) the images onto one or more CD-ROM discs. I always play the discs back to make sure there are no glitches in copying, before I reformat or erase the cards. Another obvious benefit of lugging along a laptop is that you can keep travel notes on it. Mine is an iMac G3. Some photographers burn two discs of every day's shoot, backing everything up, and mail or air express one set of discs home periodically. The laptop solution will cost between about $1,000 and $2,000, depending on the laptop's speed, memory capacity, and the options selected.

A cheaper bulk-image-storage solution is to download pictures from digital storage cards and Microdrives to devices often called "digital wallets." These are compact and lightweight; most are about the size of two packs of cigarettes. They have varying amounts of memory, on average about enough for a two-week shoot; the price range is currently about $200 to $500. Some of these wallets have screens that permit you to view and edit images, but as yet I know of none that will burn CD-ROM discs. I'm a little leery of trusting my precious digital capture to these devices, because you can't be 100 percent sure that nothing will go wrong in the downloading process. However, the Nixvue Vuescan marketed by Jobo, a respected German company, is well recommended by colleagues in the business. (Jobo markets other image-storage devices too).

With either image-storage method, you can later save the pictures to your home computer and manipulate, retouch, print, upload, or otherwise do as you wish with them, or have them permanently saved to disc and processed by a digital lab or service bureau. If you're shooting film, your storage problems are mostly about keeping the cassettes identified and also cool and dry until you can have them processed. I store film cassettes in their plastic containers in new Ziplock bags. I wrap medium-format films in foil. I mark each film cassette or roll with the date and also "A," "B," "C," etc. Then I mark each day's date and the subject matter on the bags, using Sharpie pens. I group date- or subject-related film in bigger plastic bags. Where possible, I store both unexposed and shot film in hotel minibar freezers.

Overview of Light and and Lighting

Woman in traditional head-dress, Aloha Parade, Big Island, Hawaii. With a Nikon F-100, 70–300mm lens, and SB-26 TTL flash on-camera, I added flash to lighten dark shadows on the woman's face caused by toplighting (overhead sun). Exposure was 1/250 at f/8; the flash was set at TTL mode to give –0.3 (minus 1/3 stop) of fill light for a subtle effect.

Light and Lighting Aesthetics and Skills

Using all types of light well is an extremely important photographic skill. Light is the most critical element in any picture after the subject matter, and sometimes beautiful light itself is the focal point of an image.

"Seeing" Daylight

Like all travel photographers, I rely on natural daylight for a great many of my pictures, and I have learned from long experience that dawn to early morning and late afternoon through twilight on sunny days are far and away the best times to shoot almost any subject. Predawn light starts deep blue, then the sunrise turns light to red, orange, then warmish yellow. Early morning shadows are long and delineate the texture of landscape features and massed buildings well, and there is no dust in the air. It's a great time to shoot pristine beaches and any other places where crowds of people will arrive later. I try to get permission to shoot popular tourist attractions at the time the staff comes to open up, before the general public arrives. On sunny mornings, I aim to work from pre-dawn until about 8:30 to 9:00 AM in high summer because the light is most beautiful then. One gets good light until about 10:00 or 10:30 AM in mid-winter. At any time of year, I try to avoid shooting at noon on sunny days, because then the light records as bluish to extremely blue on color film and on digital images as well.

My rule is to shoot outdoors only when my shadow is longer than I am. By avoiding midday sunlight, I also avoid getting the ugly effects of "toplight" (light from directly overhead) on people. Top-

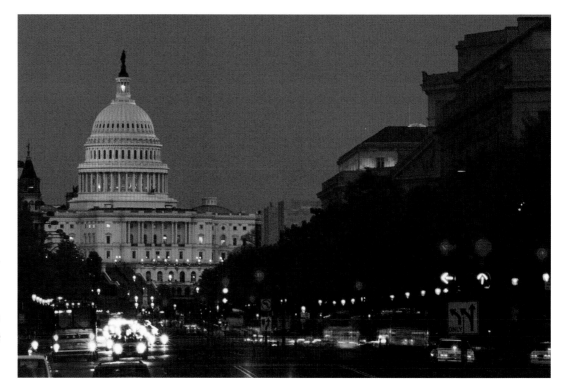

Pennsylvania Avenue and the U.S. Capitol at twilight, Washington, D.C. With camera on tripod, I used 100 ISO film with a 300mm f/2.8 Tamron lens at f/4 and f/5.6, metering off the sky. I shot at 1/4, 1/2, and one second, waiting for the traffic lights to turn red.

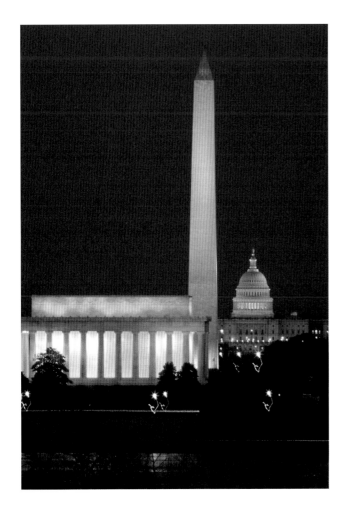

Washington, D.C. There are photos to be found everywhere in D.C., at any time of year. Line up these three famous monuments from across the Potomac, just below the Iwo Jima Memorial Monument. A 70–300mm lens at full extension was on my tripod mounted F-100 at twilight. Exposure was 1/10 at f/5.6 with 100 ISO film.

light causes dark-shadowed eye sockets and black holes under peoples' noses and chins and occurs anywhere when the sun is high overhead. Toplight also renders beaches or snow scenes as over-exposed, white, or blank and seemingly featureless, and also flattens all landscape features.

In the afternoons on sunny days, I shoot from about 3:00 PM or 4:00 PM through warm pink, orange, then red sunset light and then wait for the half hour or so of post-sunset "blue time" at twilight. That is when I take some of my favorite pictures of mountains and cityscapes.

Be aware of seasonal light, as well as light at different times of day. In summer in New York, blue time occurs from about 8:30 to 9:30 PM and the sun sets due west, at around 34th Street. In June or July, one can get great pictures of Midtown Manhattan buildings painted red or orange by the setting sun, from vantage points across the Hudson River, like Exchange Place in Jersey City and the ferry terminal in Hoboken, both along the New Jersey shore.

In mid-winter in New York, the blue time occurs at around 5:00 to 5:30 PM, and the sunset is due south of Manhattan, behind the Statue of Liberty. At 5:00 PM in December, with long lenses and the camera on a tripod, I have made great pictures of a huge sun setting directly behind Lady Liberty, also of brightly lighted downtown skyscrapers that are still separated from the deep blue sky.

TIPS FOR SHOOTING SUNRISES AND SUNSETS

Arrive at your chosen vantage point well before the event. Compose so there is foreground interest. Meter off the sky around the sun, never off the bright sun itself, or you will get underexposed pictures. Slightly misty or foggy weather usually produces fine sunset and sunrise effects, as do dust and the unsettled weather that occurs after storms. To maximize sun size, use your longest telephoto lens—400mm or 500mm both work well. Of course, use them on a tripod if possible.

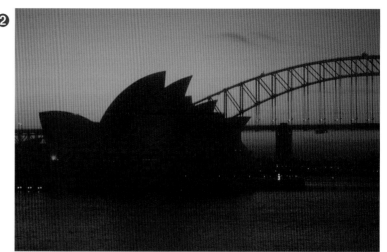

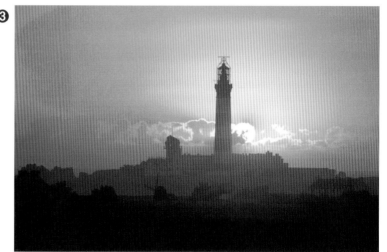

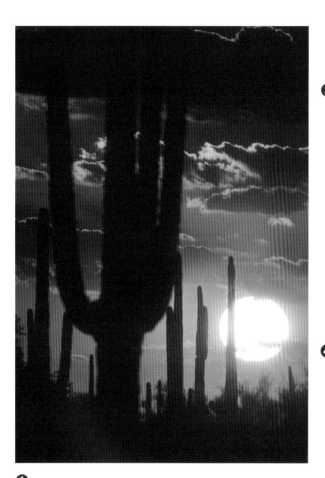

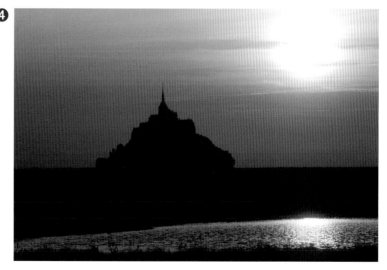

❶ Sunset in Saguaro National Park, near Tucson, Arizona. A fixed-aperture f/8 500mm mirror telephoto lens was used on a tripod-mounted F-3 camera to produce this shot. Metering off the sky with 64 ISO film, my base exposure was 1/30 at f/8 to silhouette the giant cacti. I shot two rolls of film, increasing and decreasing shutters speeds to vary effects as the light changed.

❷ Sydney Harbor, Sydney, Australia, at sunset. I was told that in August a spot known as Mrs. MacQuaries' Chair was a good place to capture both the sunset and the icons of Australia's biggest city, the Sydney Opera House and Harbor Bridge. I metered off the sky and used 100 ISO film. To the best of my recollection, exposure was 1/60 at f/4–5.6.

❸ Sunset over the Cre'ach Lighthouse, Ile d'Ouessant, Brittany, France. This shot of one of the tallest lighthouses in France was made in late August with a Nikon FM-2 and a 200mm f/2.8 lens mounted on a tripod. I drove as close as possible, then ran off road to get the sinking sun and lighthouse aligned as I wanted them. With 100 ISO film, exposure was 1/60 at f/5.6–8.

❹ Sunset, Mont Saint Michel, Normandy, France. Most of this day was gray and drizzly, but I needed this shot for a tourism client, so I didn't give up. The weather cleared by late afternoon. It was mid-June, so sunset was around 9:00 PM and I saw I was going to get lucky. I mounted my 80–200mm f/2.8 lens plus 2x tele-extender and FM-2 camera on a tripod, and waited for about an hour to get this effect. On 100 ISO film, exposure was 1/125 or 1/60 at f/5.6.

❺ Sunrise, the Jefferson Memorial, Washington, D.C. An October magazine assignment was to get "a fresh look at the Jefferson Memorial." My only instruction was not to use any color filters. I shot the monument inside and out with every lens I possessed for two full days. On day three, I arrived at 5:00 AM in plenty of time for sunrise, but didn't know if there would be a clear one. Again I was lucky, but this light lasted for less than five minutes. I exposed 50 ISO film at 1/30 at f/5.6 with a tripod-mounted FM-2 camera with a 35–70mm f/2.8 lens.

❺

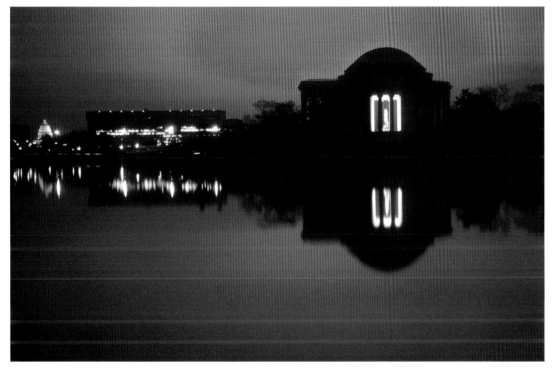

COPING WITH WEATHER ISSUES

Bad weather can mean great pictures. Keep yourself and your equipment warm and dry in winter. Keep spare batteries warm too; they lose efficiency in the cold. UV filters and plastic bags are good lens and camera protectors. Use Kleenex and a soft brush and carefully dry off cameras before changing lenses, film, or digital media. As for rainbows, if you can see one, you can photograph it.

❶ The almost-constant rainbow here is caused by late-afternoon sun hitting droplets of spray from the stupendous Victoria Falls, Zimbabwe. With a hand-held Nikon F-2, 20mm lens, and 64 ISO film, exposure was 1/250 at f/8.

❷ Rainbow over Barton, Vermont. This shot was made from the side of the highway with a Fuji S-1 digital camera and 70–200mm zoom lens. At 400 ISO, exposure was 1/250 at f/8; I made several shots and angled the scene to show as much of the bow as possible.

❸ Harrods in the rain at twilight, London, U.K. My camera and 20mm lens were mounted on a tripod on a typical drizzly November evening; 100 ISO film was exposed at 4 seconds at f/11. There are advantages to shooting in the rain at night; here the reflections brightened what would otherwise have been a black hole in my composition—a trick often employed by moviemakers.

❹ Deer and snow, Knowle Park, Kent, U.K. Exposing for snow is a little tricky—it is not an average-tone subject—but you should have no problems if you meter off a mid-toned jacket or an 18 percent gray card. To ensure getting the exposure I want, I try to lightly bracket (vary) my snow exposures.

❺ In low light, rain, or even snow, one can add TTL (through-the-lens metered) fill flash to foregrounds within flash range to brighten up a scene. This shot was made on the Ile d'Ouessant, Brittany, France, with an on-camera TTL flash. Experiment by underexposing backgrounds slightly and adjusting flash fill output settings to get just the effects you prefer. (See your camera and flash manuals.)

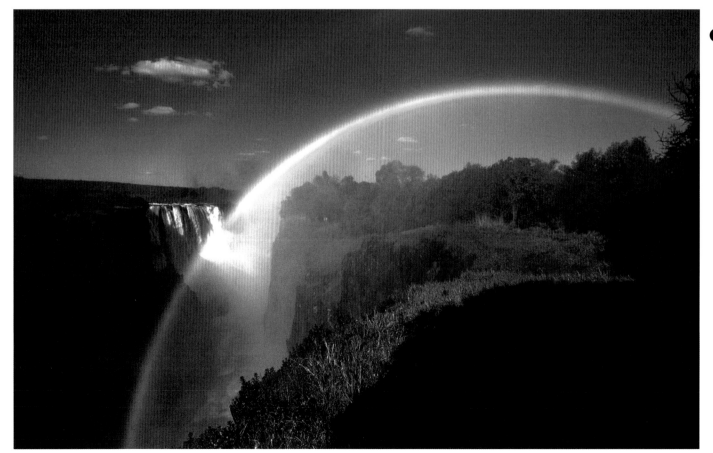

❶

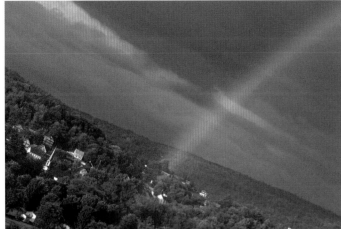

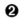

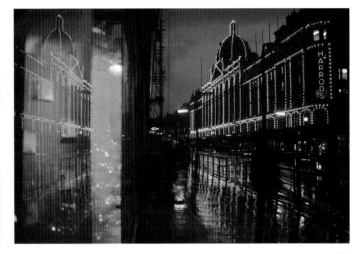

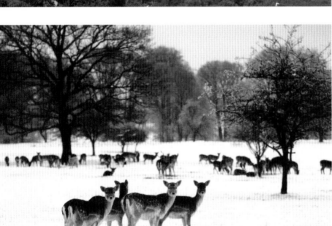

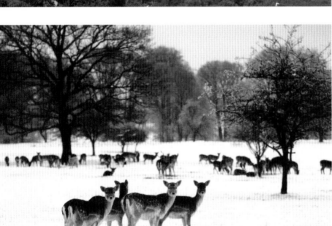

Shooting in Bad-Weather Light

You can get great travel bargains traveling out of season. But, can you get great travel pictures when the weather may not be at its best? My answer is yes, almost always, if you are patient and know a few tried-and-true tricks.

Low sunlight is warm, red, or yellow early and late; winter sun is yellowish most of the day. Such colors are exaggerated on daylight films. To get good color when shooting digital images outdoors or in the Auto White Balance mode is normally fine. For more precision, Daylight mode (or Sunny or Shade modes, if available) white balance settings may be preferred. Experiment. The white balance on many digital cameras can also be set for indoor fluorescents and for photographic or household lights and customized for special effects. (See your camera manual.) Pleasing skin tones are accepted for good color rendition. Also see "Kelvin Temperatures, Balancing Color to Light, Film and Filters," below.

In terms of improving poor light itself, you can underexpose daylight backgrounds by about one-half stop and add "flash fill" light to brighten close foreground subjects. The flash will "warm" the bluish color on your film that occurs with the high "color temperatures" of light in bad weather, and will especially improve pictures of people.

Kelvin Temperatures, Balancing Color to Light, Film and Filters

Lord Kelvin, a nineteenth-century British physicist, was the first to measure the color of light. He heated a "black body"—probably a lump of iron—until it glowed first deep red, then, as it got hotter, bright red, orange, yellow, then white hot. Finally, it emitted a bluish gas. That is why his "color temperature" ratings rise as light gets bluer. Daylight-balanced films are designed to reproduce skin tones and other subjects accurately when exposed under "neutral daylight"—defined as sunlight on a day with some clouds in a blue sky in summer months. Neutral daylight is rated at 5,500 degrees Kelvin, often written "5,500°K." Tungsten hotlights of the type used in movie and TV studios, stadiums and auditoriums, etc., are today almost all rated at 3,200°K, and Tungsten-balanced films accurately render colors exposed under those lights. Light sources often give inexact illumination of those norms at different times of day and in bad weather, and artificial light sources change color as they burn. For these reasons, a knowledge of color filters, and so-called gels or sheets of colored plastic, is essential to professional and serious amateur photographers. Professionals and others who shoot film and do not plan to scan it to computer for manipulation, retouching, or inkjet printing still need to know about how to use filters and gels. Hoya, Tiffen, and Schneider all make excellent Light Balancing and other color filters, and Rosco and Lee make sheets of colored gel. Kodak Wratten Color Compensating filters are used for precise color correction when shooting, or making traditional color prints in the darkroom. All publish free information on their products and how to use them to render color on film, a more perfect match to original subjects, or modify or change color effects for artistic/creative purposes.

Digital photographers don't use filters much, relying on cameras' white-balance setting options to capture accurate color. If necessary they can use software programs like Adobe Photoshop to add color filter equivalents or make any other necessary or desired color corrections.

FLASH AND SNOW

Get great snow scenes with almost any flash. Set your camera in manual or Night Portrait or Slow Sync mode for slight underexposure of the background. Activate your flash. The brief burst of light will "freeze" nearby snowflakes in mid-air (sorry, I couldn't resist the pun).

❶ Capitol policeman in snowstorm, Washington, D.C. Again I metered off the twilight sky, this time with a FM-2 camera and 100 ISO film, and deliberately underexposed by 1/2 a stop. My SB-24 flash in TTL mode lit the man and the snowflakes. To the best of my recollection, exposure was 1/30 at f/4 using 100 ISO film.

❷ December snow and tree, Rockefeller Center, New York City. S-2 digital camera with pop-up flash activated. 800 ISO was set on-camera, along with a 20mm lens. With the camera in manual mode, I metered off the sky, and popped up the tiny built-in flash about four feet from the statue at left. The snow on the statue overexposed slightly, but I can live with that. I sent the picture out as my Christmas greeting in 2003.

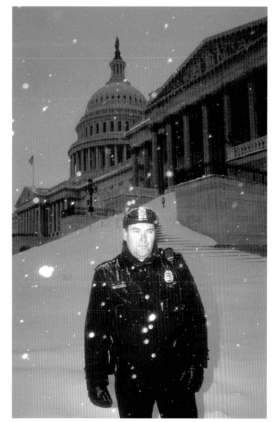

❶

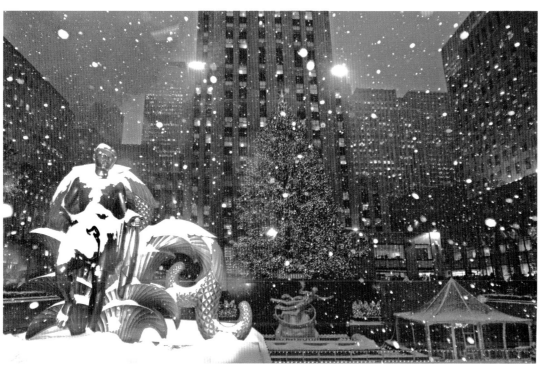

❷

In poor weather with heavy clouds, light can be flat and drab, but you still get "blue time" at twilight. If you photograph then, it doesn't matter what the weather was like during the day. If it's raining and you must take pictures, pose subjects on grass—not on shiny sidewalks or streets; in a garden, or under a tree is especially good. Choose a slow shutter speed, like $^1/_{15}$th of a second, and set it on your camera manually or use S/SV (shutter priority) mode. Then manually choose the appropriate f/stop—the camera program will select lens aperture if set to shutter priority mode. Light rain will blur at slow shutter speeds and will be unnoticeable in your pictures. Work quickly so your subject doesn't get wet, then viewers won't notice rain in the shots at all.

When shooting in snow, never meter off snow itself or you will get gray, underexposed snow. The object is for it to look white but retain detail. Meter off a gray rock, mid-toned jacket, or a gray card, then expose, holding memory by keeping the shutter release depressed halfway down before you shoot, if you can (see camera manuals for more on how to do this). A sample gray card you can use to meter off is printed on page 147. I always bracket snow and low light exposures, and often all variants from "normal" will be good, but with different "moods" or "feel."

Dealing with Light and Contrast

Contrast is the range of light, from bright highlights to deepest shadow areas, that occurs in a scene. Over-contrasty light, natural or artificial, is generally the enemy of good photographs and undesirable with almost any subject matter, because film and digital media cannot reproduce both bright highlights and deep shadows at the same time. Digital images especially must never be overexposed.

When composing any subject that is not illuminated by flat, even light, you must almost always decide whether to meter and expose for shadow or highlight detail. You can sometimes include a small bright highlight area that will overexpose in a composition without ruining a photograph, or include a small shadowed area that will record as black when the overall composition is light and bright.

Avoid including large bright highlights plus big deeply shadowed areas in the same shot. Otherwise, large parts of your composition will be over- or underexposed, or, in the worst-case scenario, you will get both over- and underexposure in the same composition.

Learn to preview natural and artificial lighting that is over-contrasty by either closing your eyes to the narrowest possible slit or viewing the subject through a deep red, blue, or green filter. Both methods will darken shadows and make bright areas stand out.

It's best to compose a photograph so that there is no more than a 2-f/stop contrast range when shooting film, or a 1 or $1\frac{1}{2}$-f/stop contrast range whenever you are shooting digitally.

Low Light

Available light is any light other than bright daylight that exists in a scene. It may sneak through a window, reflect from a neon sign, or come from ordinary room lamps.

Use fast film, set the lens aperture wide open, and rest the camera on a ledge, or brace it if you don't have a tripod, when you see something illuminated with interesting available light.

Shooting under Bright Lights at Night

If shooting where bright streetlights or bright indoor lights are present, never meter off the lights themselves, or even include bright lights in the area you meter, or you will get underexposure of the overall scene. Meter off a typical mid-toned area of a scene, or go up close to a person's face, or meter off a sidewalk or patch of grass or mid-toned wall that reflects some light. Of course, the lights themselves will then overexpose, but that won't spoil a picture.

If you use flash on shadowed foreground subjects plus the Slow Sync shutter mode to record lit backgrounds out of flash range, be aware that you may get blurred backgrounds caused by camera shake if you don't use a tripod. You might even get "ghosts" of images blurred because flash and time exposure overlap. However, persist with the technique because you can achieve some great effects with it.

Digital Images and Overexposure

Never, ever overexpose digital images. If you underexpose a digital shot, you can almost always bring it back with the help of an image manipulation program, such as my and almost every other professional photographer's favorite: the Adobe Photoshop program. This comes in full and limited edition versions. But, if you overexpose badly, the image is often gone beyond restoration and there's nothing much you can do, except perhaps try "painting" over blank areas as best you can.

Photoshop and similar image-retouching and manipulation programs can be used for both original digital capture and for images scanned to computer from film originals. Most such programs have a steep learning curve, but there are excellent books on most available. As a Photoshop user, I keep Adobe's manual close, and also rely on *Real World Photoshop*, by David Blatner and Bruce Fraser, and *The Photoshop CS Book for Digital Photographers*, by Scott Kelby.

Battery-Powered Flash Units

A detachable flash unit with a head that angles and, ideally, also rotates is any travel photographer's most compact and versatile lighting tool. Carry one everywhere and you will get many pictures that you'd surely miss without it. If you learn to use flash in a sophisticated way and not just aimed straight from the camera, you will avoid the harsh effect and prominent shadows associated with so many flash shots.

The easiest way to soften the light from a detachable flash is to use it in conjunction with angled white "bounce cards" or small light diffusers used over the flash head. Flash can also be "bounced" by an angled or rotated flash head, off reflectors, white umbrellas, white and light-toned walls, ceilings, or any nearby white surface. Set slow shutter speeds with flash—with an electronic camera's Slow Sync (or similar name) mode, to expose both near and distant subjects correctly. Slow Sync flash also makes it possible to combine both sharpness and blur in the same shot, and more. I've illustrated some possible flash effects here.

To use flash well is a skill that will serve almost every travel photographer, because lightweight

SHOOTING OUTDOORS AT NIGHT

Outdoors at night, I use my camera on a tripod whenever possible. Alternately, I use the fastest film available, rating it higher than the marked ISO speed. Then the film can be "pushed"—development time increased—by a professional photo lab, at a premium price, and an increase in visible grain. Many digital cameras like my S-2 permit setting ISO ratings as high as 1600 ISO, though "noise"—similar to visible film grain—increases considerably. If you must hand hold in low light or with long lenses, brace your camera and/or lens to minimize blur caused by camera shake. Don't meter off lights unless you can't get a reading any other way—then, open up your lens by two full f/stops to compensate for the non-average-tone subject. In addition, I always bracket night exposures, favoring slight overexposure.

❶ Chinese Pavillion, Tivoli Gardens, Copenhagen, Denmark. With camera on tripod, I metered off the deep-blue sky.

❷ Skyline, Laughlin, Nevada. A telephoto lens of 200mm or longer makes a good spot meter; here I aimed mine at the pink sky to get a reading. With 200 ISO film, and camera on tripod, exposure was 1/30 at f/2.8.

❸ South Beach Hotels, Miami, Florida. I was testing point-and-shoots when I made this picture. The camera was a Pentax model loaded with 100 ISO slide film and mounted on a tripod. I tried the camera's Slow Sync program mode, plus popped up the built-in flash for additional "fill" light on the foreground. I was pleasantly surprised with this result.

❹ Illuminations at the Eiffel Tower, Paris, France. To see if 1600 ISO could give a good result with my S-2 camera, I set that speed and used my 70–300mm f/4–5.6 lens handheld. By bracing the lens on the wall on the other side of the Seine overlooking the tower, I got this shake-free image at 1/15 at f/5.6. There was considerable "noise"—visible red, green, and blue dots—when I made an 8" × 10" print. I reduced this later by applying Photoshop's "blur" control to the red and blue layers of the image, leaving the green layer untouched.

❺ Sound and light show at the Great Sphynx, Cairo, Egypt. Again I used my long lens as a spot-meter, aiming it at the head of the mythical beast. Because that was almost always brightly lit even though the lighting color and intensity varied on other parts of the scene, I opened up my lens, one, two, and two-and-a-half stops over the indicated exposure. With 400 ISO film, a F-3 camera on tripod, and zooming in and out, my shots were made at 1/30 at f/4 and f/5.6, and f/5.6–8.

❻ Neon Sign, Las Vegas, Nevada. With 400 ISO film rated at 800, and an 80–200mm f/2.8 lens, I metered off the awning or false ceiling that now hangs over Fremont Street, downtown. Then I bracketed the exposures, but regret that I didn't record exactly what they were.

❶

❷

❸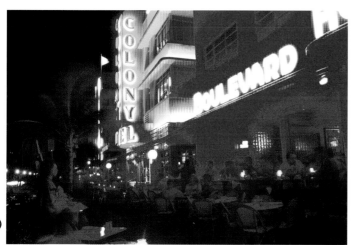

❹

❺

❻

portable battery-powered flashes can be taken anywhere, and, used carefully, can give sophisticated effects. But, quite a few serious amateurs are not too comfortable using flash. Incorporating some habits into your flash routine will help.

If you think you will need to use a TTL (through-the-lens metering) flash with your electronic film or digital camera, or an Automatic-type flash (with a manual camera), I suggest setting up and mounting the flash in advance of the shoot. Don't wait until the last minute. Most flashes are reasonably lightweight and are not much of a problem to carry for a couple of hours, and rechargeable flash battery packs can be hung from shoulder or belt loop.

Your flash can be mounted on the camera (with an appropriate TTL "remote cord" or with a "PC/synch" cord to connect it to your camera—see flash manuals), or can be set on a flash bracket, well above the camera. Using a bracket will practically eliminate the ugly "red-eye" effect of light bouncing off the retina when you shoot group pictures. Flash effects can be softened with a home-made white "bounce card" rubber-banded over your flash. Alternately, use a purpose-made LumiQuest "Pocket Bouncer" or a Sto-fen "Omni-bounce" diffusion device.

Always set flash variables before you start to shoot, and make sure your batteries or packs are fully charged. Check and re-check camera shutter speed to be sure it's at or below your camera's flash synchronization speed every time you turn on a flash. These habits should make you relaxed when shooting flash pictures.

One-Light Lighting with Flash

Rechargeable battery-powered flash units are always my preferred lighting for travel shoots because they can be packed easily, and with a collapsible reflector, a tripod, lightweight light stand, and a small white umbrella, you can easily make well-lit portraits and group shots, food and still-life compositions, virtually anywhere. Camera manufacturers and independent flash brands with a Guide Number (GN)—a manufacturer's power rating—of 120 in feet with 100 ISO film, will do fine for most serious amateur photographer's flash needs. Electronic/TTL models currently cost from around $120 to $350; automatic flash units cost from $75 to about $300.

Your only problem using any of these at home or overseas will be recharging the batteries or packs. For more on that subject, see "Foreign Electricity Summarized" on page 37, as well as the diagram illustrating foreign plug adapters and voltage transformers on page 147.

Minimizing the Limitations of Built-in Flashes

Just about all point-and-shoot and moderate-price film and digital cameras made today include a tiny built-in flash unit. These flashes can be useful as fill light in bright daylight, and will reduce dark shadows on faces. Shoot at close distances if you stop the lens down in bright sunlight. Serious photographers will soon learn that little can be done to soften the harsh effect of built-in flashes. These also often cause the ugly red-eye effect that can mar people and group shots. Red-eye is caused by the flash close to the lens reflecting off the red interior of the retina of the eye. I do not have much luck with "red-eye reduction" flash modes, but by aiming the camera and built-in flash slightly down on people, pets, etc., I do manage to avoid most red-eye.

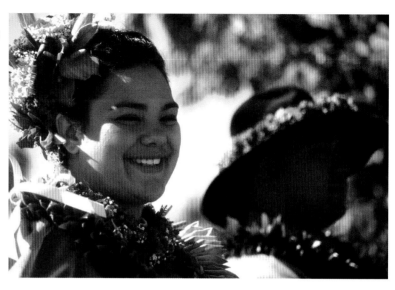

"FILL FLASH" IN SUNSHINE

A detachable, adjustable TTL (through-the-lens metering) flash unit can be invaluable on your travels. To lighten close-shadow areas, just set the camera to expose for the brightest part of a scene or subject, using manual or program modes. Then activate your flash set to TTL mode. It will deliver the correct amount of light—good flashes even permit you to vary the fill effect. Small, built-in flashes will also fill shadow areas within the flash's range (see camera manuals).

❶ Couple in island dress, Aloha Parade, Big Island, Hawaii. F-100 camera, 100 ISO film, 70–300mm lens, and SB-26 flash on-camera. Exposure was 1/125 at f/11 with Nikon SB-24 flash.

❷ Ile d'Ouessant, France. Rocks on the north shore. I added TTL flash fill to this landscape to open up the deep foreground shadows at left. The technique must be used at close range to be effective. Here I exposed for the background and worked with a 20mm lens. With 100 ISO film in my Nikon N-90, exposure was 1/125 at f/11 with Nikon SB-24 flash.

Foreign Electricity Summarized

In North and most of Central and South America (not Brazil), and in Japan, 110-volt household current and U.S.-style two- and three-prong plugs are standard.

In Europe, most of Asia, and most of the rest of the world, the standard current is rated at 220–240 volts. You will have to carry a transformer and power strip plus a plug adapter to travel in any of these regions with electronic flashes, digital cameras, laptop computers, and more. Electric plug designs vary in different parts of the world. (See diagrams on page 147.) If you forget or can't find something before you travel, don't panic; transformers, power strips, and U.S.-to-foreign adapter plugs can be found in almost all big cities worldwide. Disposable AA-size batteries can now be bought everywhere, though I would not store unknown brands of these in valuable electronic equipment after you've finished shooting. Carry all the small lithium or button batteries you will need with you; they can be hard to find and expensive even in remote corners of the United States.

Overview of Skills

Tourists landing on Baltra
Island, Galapagos, Ecuador.
FM-2 camera, 50 ISO film,
20mm lens. Exposure was
1/125 at f/5.6.

What Makes a Good Travel Photographer?

The travel photographer should be well rounded, comfortable shooting different things, and, of course, competent at camera handling. You should know how to use lenses to your best advantage, from extreme wide-angles to long telephotos or zooms. A fine sense of composition—the ability to make interesting and powerful arrangements of subject elements on a flat "film plane"—is a paramount travel skill, too.

The good travel photographer must be able to "see" and use natural and existing light to its best advantage, whether it be bright daylight, sunrise or sunset, twilight, or even rain or snow, as well as know how to work under existing artificial indoor or outdoor lighting.

The excellent travel photographer should have all of the above skills plus an ability to work fast under pressure, and to add and control flash and other photographic lighting sources to a scene or subject when needed. A professional photographer must know how to light a scene or subject from scratch on occasion, even if he or she prefers a natural light "look." Most importantly, good travel photographers should contribute a personal style or point of view to both individual images and travel stories.

The great travel photographer (I make no claims to this, though I'm always aiming for the pinnacle) most of all will have a passion for whatever she is shooting at that particular moment, whether it is a once-in-a-lifetime event or a fairly routine experience. You need this concentration to make the best possible pictures of any subject. Without it, you won't search high and low for that one perfect angle, you won't go back and re-shoot when the light starts to look magical—more than once if necessary—and you won't suddenly be inspired to completely rethink a picture story. When I'm in the middle of a shoot, that's all I think about—I often don't even hear people talking to me. The only conversations I will have at such times are minimal and must be related to the shoot.

An excellent travel photographer who is sharp from plenty of recent shooting will have all of the above skills and attributes plus excellent reflexes. He should try to be fully aware of what's going on in the vicinity of the shoot as well. This can enable him to anticipate action before it happens and occasionally capture those unplanned "magic moments." Surprisingly often I will step to, say, the left, and something interesting appears in my viewfinder. I'm not psychic, but I do try hard to be sensitive to any small visual and aural changes in my surroundings.

All these attributes sound formidable, but all can be enormously improved by shooting often, being critical but not destructive of your own work, editing carefully, and re-shooting when you have the opportunity to improve something.

Visual Skills

Of all the visual skills, the ability to make clean, uncluttered compositions is the one I value most. (Other photographers may have different priorities.) To my end, *always study everything you photograph through the camera viewfinder.* This sounds elementary, and is, but too many inexperienced photographers see a scene, put the camera to their eye, and snap, without taking the time to study whether a change of angle or height, or zooming in or out, or using a wider-angle lens would improve the shot.

Always be aware of backgrounds. Modern single-lens reflex cameras show a scene with the lens aperture "wide open" (at its maximum aperture). This gives a bright view and aids quick autofocusing. But, it gives you an inaccurate view of the "depth of field" (zone of sharp focus) of the subject, and you may fail to notice something distracting in the background. Use your camera's Stop Down Preview feature to preview depth of field. You will soon get used to viewing a somewhat dim subject, and can then see unwanted or unpleasant elements and make choices about how to deal with them. You usually do this by moving yourself or your subject.

There is no better way to improve your eye than to study the work of visual masters. Go to museums and look at the works of great painters as well as photographers.

Working with Depth of Field

Depth of field is the zone of sharp focus from front to back in any scene you photograph. It varies according to lens focal length and aperture selected, as well as the point within the scene where you focus.

Depth of field is shallow at wide apertures, deep at small apertures. Wide-angle lenses inherently have great depth of field, and telephotos shallow depth of field. Use wide-angle lenses at small apertures for landscapes that are sharp from front to back, and telephoto and "macro" (close-up) lenses at wide apertures for shots of sports events and portraits, and flower pictures with non-distracting, extremely soft, out-of-focus backgrounds.

Maximize depth of field with any lens at any aperture by remembering the Hyperfocal Distance Law. This law of optics states that the zone of sharp focus extends one-third in front and two-thirds behind the point of sharp focus, except for extreme close-ups. Then depth of field, while shallow, is about equal in front and behind the point of focus.

The maximum depth of field possible with any lens occurs when the lens is set to its smallest aperture (but note that this is not necessarily the *sharpest* aperture) and focused one-third of the way into the composition.

To get the most accurate view of the zone of sharp focus from front to back in any scene, you must stop a lens down to the actual "taking" aperture selected for the shot. Do this by pressing the Stop Down Preview button or lever on your camera (if it has one). See your camera manual to locate this extremely useful feature (the button/lever is usually placed close to the lens). I highly recommend checking to make sure any new camera you consider has this feature before you buy.

Maximizing the Possibilities of Wide-Angle Lenses

Most serious photographers own at least one moderate wide-angle lens of about 35mm, or a wide-angle-to-zoom telephoto lens of 35–70mm or 28–80mm. They zoom wide for landscapes, and sometimes for interiors, but aren't too impressed with effects achieved *because these lenses aren't wide enough to do anything spectacular.* The 28mm lens is a favorite of mine for location portraits showing people in their surroundings, but for landscapes and buildings I rely on 20mm and even a 14mm lens. *Digital shooters should remember that most current digital SLR cameras multiply lens focal lengths by a factor of about 1.4.* My 14mm lens is equivalent to a 20mm lens when used on my digital SLR camera. A 35mm lens becomes effectively a 50mm lens, and a 28mm lens becomes a 40mm lens on most digital cameras.

THINKING ABOUT COLOR

Often it's good to decide in advance whether your subject is better in color or black-and-white. These shots are clearly meant to be in color.

❶ Beach cover-ups, Jamaica. Fuji S-2 digital camera, 100 ISO setting, 50mm lens. 1/250 at f/11 in partial shade.

❷ Newly painted, traditional red telephone booths in London, England. Nikon FM-2 camera, 50 ISO film, 28mm lens. 1/250 at f/5.6 in bright afternoon sunshine.

❸ Open-range landscape, Nevada. Nikon F-100 camera, 100 ISO film, 80–200mm zoom lens at about 80mm, 1/250 at f/4 in early evening with added TTL flash fill brightening the sign.

❹ Bullfight, Madrid, Spain. I don't love bullfighting, but I do love this early experiment of mine, which is influenced by the late great Ernst Haas, who was the first to make such blurred images intentionally. If I remember correctly, I put a polarizing filter on the camera to reduce light by two f/stops and shot at somewhere around one second at f/16 on 25 ISO film. Duping this slide increased the contrast.

❺ A seascape made on film in Bora Bora, French Polynesia. This blue was done with 50 ISO film. I metered off the sky and bracketed the exposures by 1/2 stop over and under normal.

❶

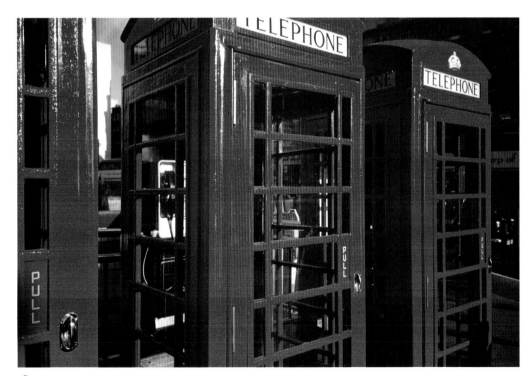

❷

❸

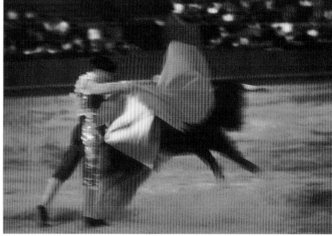

❹

❺

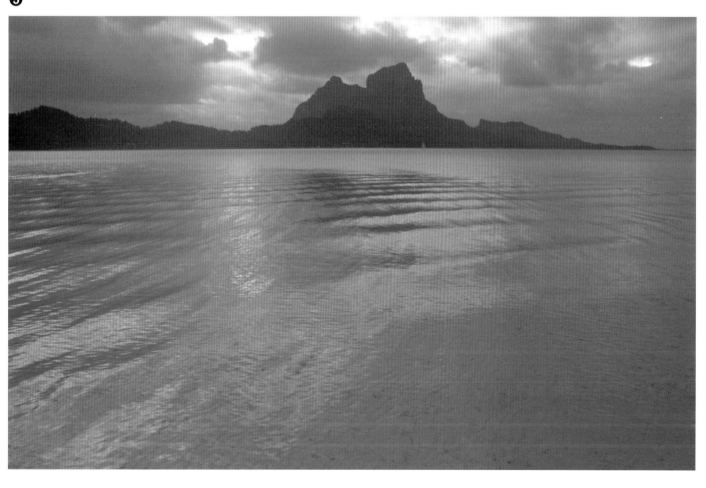

THINKING IN TERMS OF BLACK-AND-WHITE

Black-and-white photography has made a big comeback in recent years and has always been a gallery/fine art classic. Black-and-white pictures are once again published in top travel magazines as well as in books and newspapers. With black-and-white, tones and mood, as well as the subject, lighting, and composition of the picture are equally important. Many people think that shooting black-and-white images is the best way to learn to "see" like a photographer.

❶ An outbacker and his dogs were photographed backlit by low afternoon sun near Yulara in Australia's red center. Nikon FM-2 camera, 20mm lens, 400 ISO film rated at 200, with development time reduced to lower contrast; exposure was 1/250 at f/4.

❷ Mistletoe balls in poplar trees, Normandy, France. I made this early-spring landscape with my S-2 camera rated at 100 ISO with a 70–300mm zoom lens at about 200mm (effectively about 300mm on that digital camera). I handheld the camera and so chose a high shutter speed to prevent blur caused by lens shake, and exposed at 1/500 at f/5.6. With digital originals, or with slides scanned to digital, it is easy to transpose images to black-and-white from color, as this one was.

❸ Mijas, Spain, is a blindingly white-painted village. I decided to silhouette the dark figures by metering off the buildings, then opening the lens up one f/stop to compensate for the non-average subject. I used a Nikon FM-2 camera, 80–200mm lens set at about 80mm, and 400 ISO film rated at 200 to lower contrast. Exposure was 1/500 at f/5.6.

❹ Czech Republic, Prague. Historic Jewish cemetery on a drizzly day. I underexposed slightly to convey the mood I wanted.

❺ A market day in Normandy, France. With a 14mm lens on my S-2 digital camera, I stood close to the dishes so they were the main design element. In spring sunshine at a 100 ISO camera setting, exposure was 1/250 at f/11. Again this shot was transposed from color.

❻ Lumber Baron's Mansion, Eureka, California. From some distance, I used a 43–80mm zoom lens and was able to frame the house without distortion. The strong design works well in black-and-white; I used an orange filter to deepen the blue sky. Film and exposure were not recorded.

❶

❷

❸

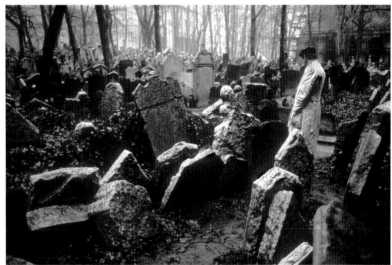

❻

❺

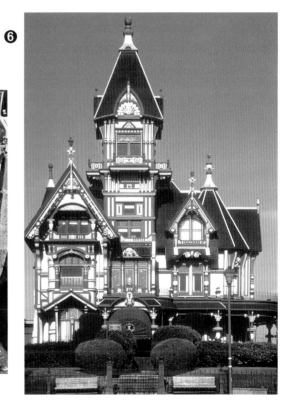

PROPERTIES OF TELEPHOTO LENSES

Telephoto lenses and tele-zoom lenses compress landscapes, can fill a "frame" with a face, and bring all distant subjects closer. Lenses of about 80mm and up are considered telephotos. Telephotos inherently have relatively shallow depth of field (zone of sharp focus), which means you can easily throw unwanted background detail out of focus by choosing a wide lens aperture, or, if you wish, reversing that effect. With long telephoto lenses (200mm and up) you must set high shutter speeds, brace the lens against a chair, wall, or tree, or (best) use a sturdy tripod to eliminate the blur often caused by long-lens shake. The distance from your subject, lens focal length, and the shutter speed, aperture, and point of focus chosen will determine the various effects that can be achieved with telephoto and long zoom lenses.

❶ Giraffes at dawn, Serengeti National Park, Tanzania, Africa. Nikon F-2 camera, 500mm fixed-aperture f/8 mirror telephoto lens, 64 ISO film. Telephoto or zoom lenses are essential for most wildlife photography. This original was shot in color at dawn—the sky was a dull orange. Because of the strong subject matter and design, I think it works well in black-and-white too. I was in a van with a shooting platform, and the camera was on a tripod. Exposure with 64 ISO film was 1/30 at f/8.

❷ Clock and decorations on the Cathedral in Taxco, Mexico. I shot with the Fuji S-2 camera and an 80–300mm zoom. I set the ISO to 400 so I could use a high shutter speed—set 1/500 at f/5.6 by metering off the tan building—and made several exposures to be sure I had framed the image accurately with the camera handheld. With digital, it's easy to shoot in color and later convert to black-and-white if desired.

❸ Traditional Horsemanship Demonstration, Marrakech, Morocco. A monochromatic color shot that also works transposed to black-and-white. The heavy dust was backlit by late-afternoon sun. I used a Nikon FM-2 camera, an 80–200mm zoom telephoto lens, and 64 ISO film. Exposure was 1/125 at f/5.6 handheld; the moving figures show a slight blur.

❹ & ❺ Young man with panda hat and panda portrait. Both pictures were made at the National Zoo in Washington D.C. with my first digital camera, the 3mb Fuji S-1 Pro (now used as a backup) with a 300mm f/2.8 telephoto lens mounted on a tripod. At a 400 ISO setting, exposure on a cloudy bright day was 1/500 at f/5.6.

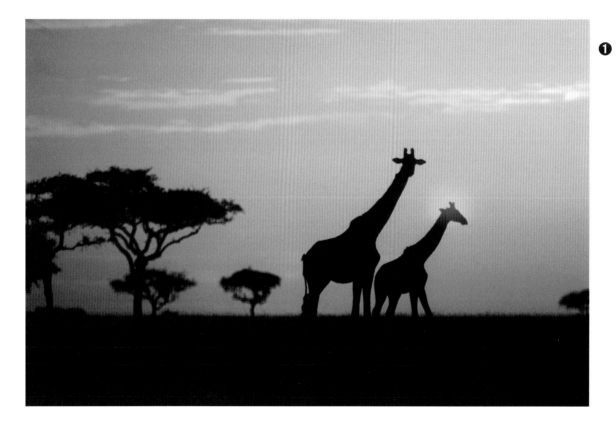

❶

❷

❸

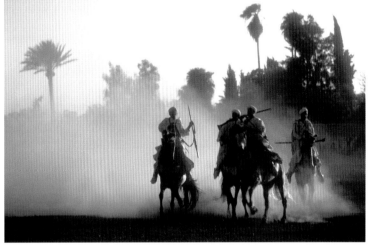

❹

❺

MAJOR ADVANTAGES AND PROPERTIES OF WIDE-ANGLE LENSES

Wide-angle lenses are not fully appreciated by many inexperienced photographers. But they have great inherent depth of field and render foreground subjects large in relation to backgrounds, making them ideal for recording sweeping landscapes, people in their environments, and architectural and interior subjects. Note that care must be taken to hold extreme wide-angle lenses level (a tripod is a must for critical architectural or interior work), or annoying distortion can result.

1 Folk art in El Salvador. I aimed an F-3 camera with a 20mm lens slightly down while tilting the lens forward to maximize depth of field. This rendered both the craftsman's hand and the tiny foreground objects in sharp focus. Low-angled sun shining through a nearby door lit the subject. Exposure was 1/60 at f/8 with 64 ISO film.

1

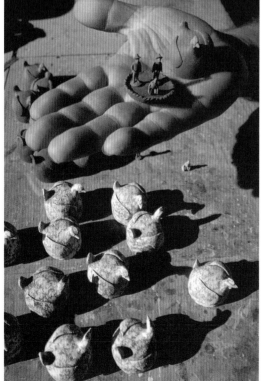

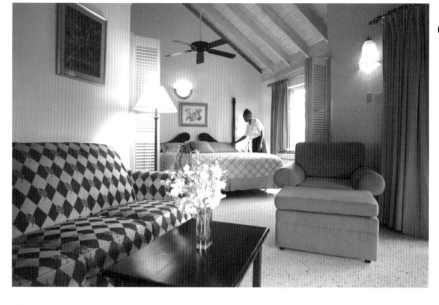

2

2 This suite was shot at the Sea Splash Resort in Negril, Jamaica. I used a 14mm lens on an S-2 digital camera (the equivalent of a 20mm lens on a 35mm film camera) and carefully leveled the tripod-mounted camera to ensure the walls appeared vertical. Exposure was 1/10 at f/5.6.

3 Auditorium, Wielki Theater, Warsaw, Poland. The shot of this huge auditorium was made during the intermission of an opera performance. I know that I used 400 ISO film, that I metered off the mid-toned ceiling and bracketed several exposures, but don't remember exact camera settings. The building's curves meant that the slight distortion from handholding my F-2 camera with 20mm lens was barely evident.

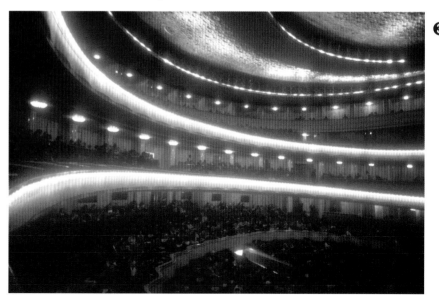

3

I heartily advise serious travel photographers to invest in the widest-angle lens they can afford. Some landscapes, architecture, interiors, and still lifes shot with extremely wide-angle lenses are shown on page 48. Using wide-angle lenses well takes practice. An extremely important equipment-handling skill for travel photographers is to be able to avoid unnecessary distortion when shooting architecture, interior, and still-life subjects with wide and super-wide-angle lenses. Wide-angle lenses must always be leveled extremely accurately, or the result will be images with tilted lines or off-kilter perspective. Minor tilts used in a controlled way are acceptable even for publication, but extreme distortions, while they can occasionally work for special effects (as in the classic horror movie *The Cabinet of Doctor Caligari*) normally ruin almost any picture.

Note that all wide-angle lenses inherently distort to a greater or lesser degree even when leveled perfectly. (Professionals and architecture photographers, who must have absolutely precise lines, level their specialty cameras by mounting them on a tripod that adjusts horizontally and vertically, and check all angles with the aid of a spirit level.)

Inherent wide-angle lens distortion occurs only at the two sides (if a camera is leveled horizontally) or at top and bottom (if aimed vertically). If you level a camera carefully, and place faces or human figures or important still-life objects well away from the edges of a wide-angle lens composition. Distortion will not be noticeable.

When shooting architecture, place the camera so it's about mid-high to the space or building, if that's possible. Level the camera by checking that the building and wall lines look vertical in the camera viewfinder, and that setbacks, shelves, cabinets, or the floor or ceiling lines look horizontal. Then shoot. This is simple if the camera is on a tripod that can be adjusted both horizontally and vertically.

Skilled travel photographers who are not architectural specialists, myself included, but who have practiced a lot, can do a pretty good job of accurately framing wide-angle interior or exterior building shots so they are not distorted without the use of a tripod. But I prefer not to take chances, and always use a tripod with any complex indoor set-up that includes people or still life as well as architecture.

Outdoors, moving back from a building and shooting it with a moderate telephoto lens from some distance or from a nearby high building or other high viewpoint may be a better solution to distortion than having to tilt a wide-angle lens up to include the top of a building. Tilting a wide-angle lens up will always make a building or room appear to lean backwards. But if you must tilt a lens up to include a roof, spire, or ceiling, level the camera carefully so the tilt effect is even and not leaning toward one side or the other.

Special P.C. (perspective correction) lenses are made by Nikon, and T/S (tilt/shift) lenses by Canon and Olympus. They all work well when moderate tilt correction is sufficient. To the best of my knowledge, none are autofocus or work with digital cameras.

Medium- and large-format cameras that incorporate "swings" and "tilts" for sophisticated perspective correction are made by Arca Swiss, Cambo, and Linhof, among other companies. Digital backs for these cameras are available (see Resources).

Interpersonal Skills

Getting along well with all kinds of people all over your own country, and in foreign countries too, is of great importance to travel photographers. The ability to persuade people that helping with your photographic project is interesting, of possible benefit to them, and will be fun too, is a gift that can be cultivated.

I always try to have a personal chat with everyone before getting down to business. Use any visual clue that you spot to break the ice; I often rely on time-tested general subjects. Young men like sports everywhere, in my experience, and an enquiry about a local team, or even an international star who's from that country or region can be a great icebreaker. Small-town Americans enjoy telling you why they like living where they do; in England, the weather and flower gardens are surefire conversational gambits with just about anyone. Business people don't like to waste time, but you can ask about family in pictures spotted on a desk, or admire their office furnishings or their view to get you started. I will buy a small object in a crafts market, then ask if it was made locally.

On the road, you must be able to talk to strangers, persuade them to pose for you in a tree, allow you to shoot in their restaurant, open their bakery early, or admit you by a side door into a sold-out concert or soccer game. Those are just a few of the thousands of favors I've talked people into granting me on the road.

Language and Communication Skills

Languages are obviously a great advantage to a travel photographer, but they aren't an essential. If I can communicate even badly in a foreign language I will try to do so. I speak pretty fluent French, and can manage basic communication in Italian, Spanish, and German, but my massacre of these languages usually makes people laugh a lot. Elsewhere, I'm fluent in sign language and in smiling a lot, and learn at least the words for "hello" "may I" "please" and "thank you so much" wherever I go.

Phrasebooks help a lot, too. I've used one on remote Greek islands. My daughter, who says she is language phobic, got around brilliantly on a recent trip to Paris with no French whatsoever, plus a phrasebook and a street guide. (She says most young Frenchmen speak English well).

Finding and Working with Assistants

My photography is not high-tech. I don't normally use complicated light-setups for my mostly editorial-style travel pictures, so I don't usually take along a trained professional photo assistant when I travel. But, if I have a big-budget, complex travel promotion or advertising shoot to do, I certainly will bring along one or as many photo assistants as I feel are needed to do the job properly.

I often travel with a close friend or friends when on vacation (though most of my vacations are photographic and most of my friends are photographers themselves). We will discuss priorities in advance, and agree to spend some part of each day separately. Otherwise, we would tread on each other's toes.

On jobs, however, I almost always travel alone. Then I like to hire assistants on the spot if needed. They don't have to have photographic skills. When in Asia or Central Europe or Africa, or anywhere else where the local language is a total mystery and communication a necessity, I will try to hire an English-speaking student, or an off-duty hotel worker to act as my assistant and translator.

Ideally, they will have a car, or I'll rent a car if needed. A taxi driver recommended by a good hotel who speaks some English can be an excellent guide—the English need not be perfect, but be sure to negotiate the rate by the hour or day in advance.

Professional photo assistants and "location scouts" can be found in many big cities and some popular resort areas in the United States and overseas; you can locate them through classified phonebooks and local tourist information offices, which can often be extremely helpful. It has been my experience that photographers on the spot are often happy to assist, for a fee of course, and that they are often generous with local knowledge even if they're not interested in working for you.

John O'Leary, a resident of Mexico and professional location scout who mostly works on big TV and movie shoots, assisted me on a recent trip. With him I crammed into a week what would have taken two weeks or longer on my own. He was of tremendous help when I injured my thumb in Oaxaca. For more information about how John and I dealt with this injury, and how you can deal with the possibility of sickness and injury while traveling, see "Medical and Other Travel Insurance" on page 102.

My assistant in Mexico took me off the beaten track. This "grab" shot was made outside his house in Chollula, near Puebla.

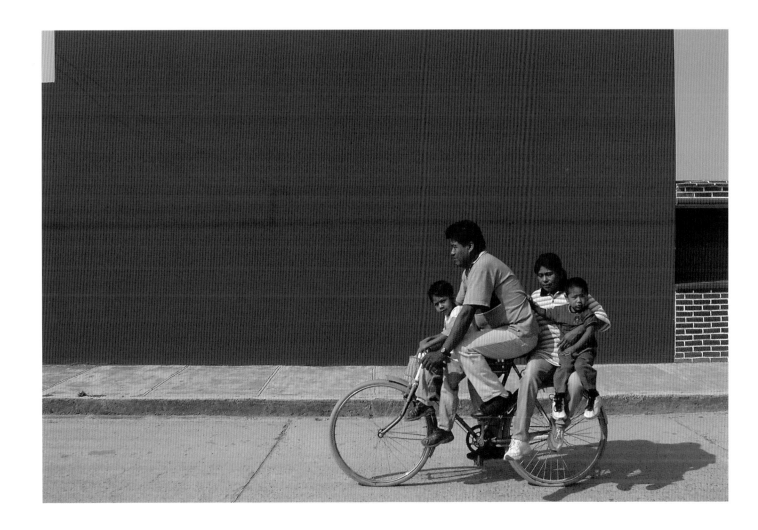

MARKETS

If you are sensitive to people and don't interfere with commerce, markets are a fine place to meet locals. I often hang about with my camera held eye high and clearly visible, and watch responses. If someone smiles, I feel free to approach. Of course, you get an occasional strong negative also then, I smile and wave a "no, I'm not going to photograph you if you don't want it." I often buy something after asking people to pose rather than tipping them, which helps my subjects.

❶ Girl at tropical flower stand, Maui, Hawaii. I asked this young girl's mother for permission to photograph her. They then presented me with this gorgeous bouquet. I made sure to send prints as a thank-you. Nikon F-100, 100 ISO film, 28mm lens. Exposure was 1/60 at f/5.6 on an overcast day.

❷ This fishmonger and I communicated perfectly with smiles and gestures in Istanbul, Turkey, and I love this shot. I made two rolls of pictures of him with a 20mm lens and 64 ISO film exposed at 1/60 at f/4 in deep shade. I bought a lot of fish I didn't need as a thank-you.

❸ The Greenmarket, Union Square, New York City. The colorful place is four blocks from my studio and I often shoot there. This picture was made at about ten o'clock on a late-May morning, when the sun was already high. My Fuji S-2 was rated at 100 ISO, and exposure was 1/250 at f/11 with a 28–70mm zoom lens.

❹ The Greenmarket, Union Square, New York City. This shot was made from the same spot at about 5:30 the same evening as the photo above, and illustrates what a difference choice of lens and prevailing light can make. I spotted the charming family and asked them to pose. My S-2 now with a 20mm lens, was still rated at 100 ISO. I held the lens close to the tulips to exaggerate their size, metering off the flowers that were rendered almost translucent by low sun shining so it backlit them. Exposure was now 1/250 at f/5.6–8. I sent the family digital prints.

❺ Marché de Passy, Paris, France. I shot the upscale market interior with an S-2 digital camera and 14mm lens placed close to the broccoli and leveled carefully. Exposure was by the camera's built-in meter.

❶

❷

❸

❹

❺

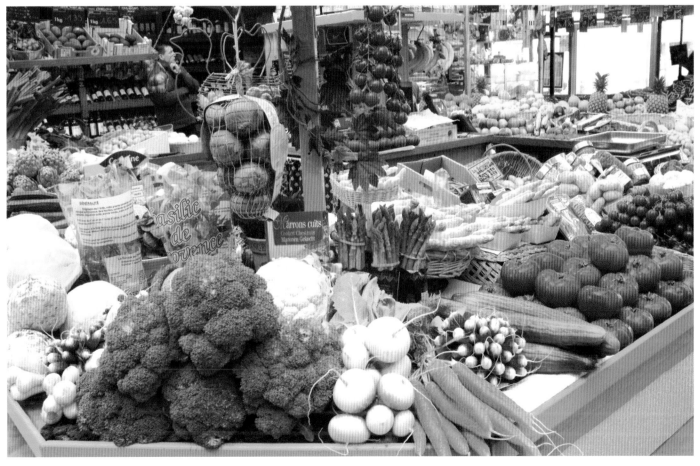

VARYING COMPOSITION

Many pictures can be made from a given landscape, street scene, still life, or even human subject. Practice by moving the camera viewfinder around while held to your eye, varying lenses if you wish. Here I was on the "motu," or coral reef, looking at possibilities of framing the island of Bora Bora at twilight. While all shots are usable, I prefer one of the pictures to all the others. (You may disagree with my choice!)

❶ – ❸ Bora Bora, French Polynesia. With my favorite 20mm lens, an F-100 camera, and 100 ISO film, I exposed by metering off the sky, bracketing exposures as the sun went down rapidly, as it does in the tropics. Base exposure was 1/30 at f/8, f/5.6 or f/4. To hold both trees and island in sharp focus, I chose moderate f/stops and focused one-third of the way into the composition to maximize depth of field. (The rather low shutter speed, 1/30, is handholdable without blur only if you use a wide-angle lens and are careful.) I bracketed, shooting at "normal" as well as plus and minus one-half and one full f/stop over and under exposure for each scene.

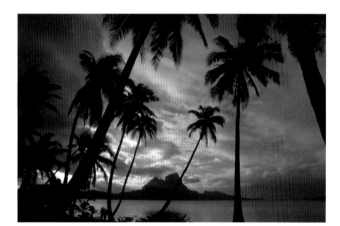

❶

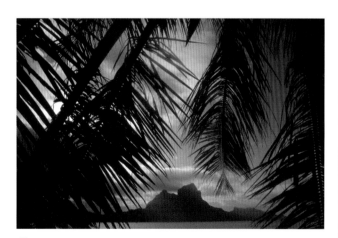

❷

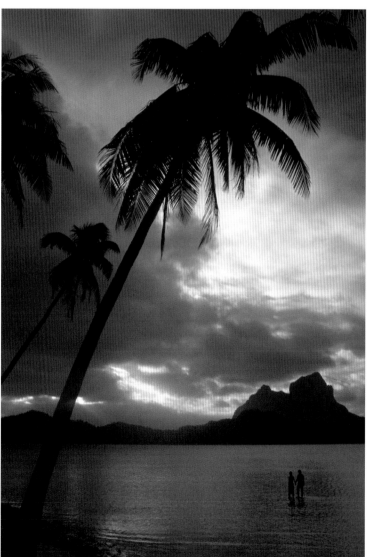

❸

About Guides

In case any would-be professionals who want to know more about shooting travel jobs are reading this, know that tourism clients almost always have at least one person on the spot who will be assigned to escort and otherwise help you during your visit. Since any and all of the help this person gives you will probably be in addition to her regular workload, be extremely nice to her!

While hiring guides and/or translators anywhere costs money, if you realize how much help they can give you in terms of covering ground and taking people pictures, you will often find them worth the investment even if you are not reimbursed for the expense.

Caution: Never, ever pick up anyone who approaches you on the street offering to guide you around; there is too much risk of crime attached (of course, often I will accept a gracious offer of extremely local directions). Note that this warning does not only apply to third-world countries!

Finally, I avoid hiring professional tourist guides under almost all circumstances. In my experience, they all think of foreigners as walking cash machines, they prefer to work with big groups, and if they do condescend to helping an individual on a slow day, their main interest will probably be to steer you into cousin so-and-so's shop, where they hope you will make a large purchase on which, of course, they will get a commission. Maybe I'm prejudiced; there are undoubtedly some talented, honest local guides somewhere. I prefer to work with local students, off-duty hotel staff, or, excellent if available, a local photographer or location scout. You can find these guides through the English departments of local universities, the concierge of your hotel, or newspaper offices, and even the telephone directory or the Web.

You can find graphic images anywhere, even if they don't fit into a particular category. This door was shot with a digital camera in Jamaica.

PART V
The Approaches

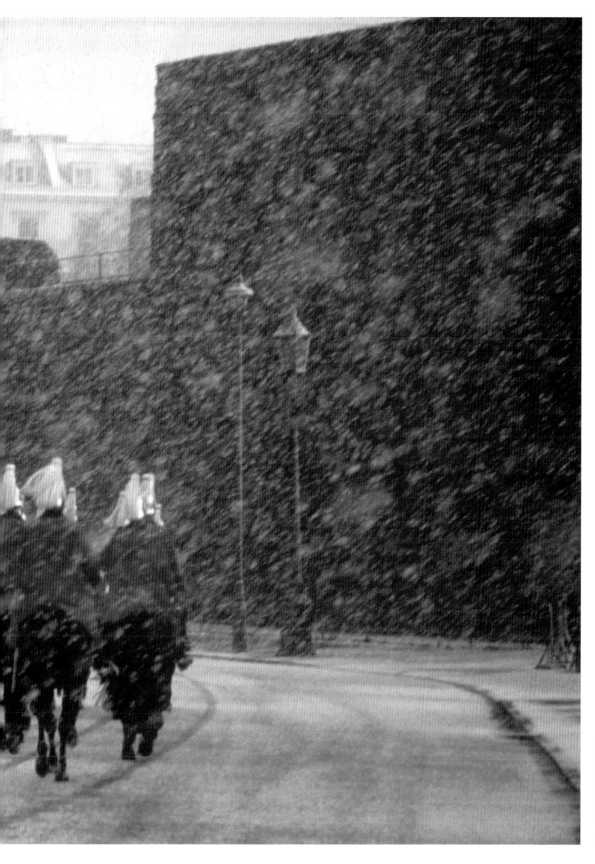

Horse guards in the snow, London, U.K. 64 ISO film, Nikon FM-2 camera, and 28mm lens. Exposure was 1/60 at f/4 in heavy overcast.

What to Shoot?

Before you go on any trip that is important to you photographically, you may want to think about what you want to achieve: Are you looking for a fine record of a family vacation to be placed in an album or on the Web? Fine art images that you hope or plan to exhibit? A magazine-style picture story about a destination? Or do you hope to market the images as stock? Do you love to photograph people or shoot landscapes or wildlife? Are you more interested in architecture or in cultural events? These factors may influence your planning—the places you visit, the best time of year to go, the equipment to carry, and how you will get around. Of course, you can also just want to enjoy a well-earned vacation and have fun taking pictures too, and decide what it all means when you get home!

People Pictures

To maximize opportunities for people photography, it's a good idea to go to someplace where there are good crowds (a popular resort area, for instance), or plan to be somewhere when an important event is taking place. I'm known as a "people photographer." When photographing people, I love festivals, rodeos, parades, public holiday celebrations, and more. In these contexts, I then try and get close to people, and not just "snipe" at them with long lenses. I strive for intimacy, and to show folks as distinct individuals and not just symbols of life in Paris, Japan, Iowa, or wherever. To this end, I may spend a fair amount of time talking to and even "directing" an interesting man or woman. After chatting with someone for a while, I can sense when I can move in closer without being offensive and ask my subject to move or pose. Quite often, I will end up just a couple of feet from my subject, talking to them all the time while I'm composing shots with wide-angle lenses.

I personally don't care for pictures of people unaware that they are being photographed. I always feel that those shots of big heads have an aspect of trophy hunting about them. I like best to show people who have consented to let me photograph them in their surroundings. Then, it's up to me to catch those spontaneous moments and movements that reveal someone's personality and even sometimes have a magical quality.

Of course, there are also many occasions, on busy shopping streets, or in amusement parks, or at political rallies, parades, sports matches, and the like, where you can't get close to ask for a person's cooperation. Then, I strive to catch interesting juxtapositions and moments of peak action. One thing I watch for when shooting in crowds is to avoid showing anyone disfigured or handicapped or wearing bandages, or who is obviously ragged and homeless—it's surprising how many such poor folks there are in any busy place. To photograph them would be exploitation, in my opinion; also, they are likely to get angry if they see you doing it. To show sad people is not part of true travel coverage, anyway. (If you prefer to shoot difficult subjects, you are a hard-core photojournalist, not a travel photographer—good luck to you!)

Approaches to Photographing People You Don't Know

Many excellent photographers have problems photographing people. Here is a short list of my techniques:

- Work with a moderate-size lens on your camera. Big telephoto lenses scare people off. I most often work with a 20mm lens on digital cameras or a 28mm lens when shooting film, to show people in their environment. I use a 50mm on my digital camera or 80mm lens with film, for when I occasionally want frame-filling portraits.
- Rule number one is always: Talk to people. Start up conversations with interesting folk you want to photograph. Admire a child or a dog, or ask about a beautiful fabric or the flowers someone is selling in a market. Use any visual clue you can find to start a conversation. If you don't know the language and don't have an interpreter, try using sign language and smiling a lot. This often makes people laugh. Then, gently raise a camera, and by raising an eyebrow and pointing at the camera, pantomime the "May I take a picture?" question. People are far more likely to respond positively than if you try to shoot cold. Then, keep on talking as you photograph. This relaxes people and makes them forget about the camera; and if they don't understand what you are saying, it often makes them laugh.
- Hang about in places where people are not too busy, on a beach or at a country fair, for instance. I keep my camera held in one hand at chin level, so people can see what I'm doing. I almost never try to sneak pictures of people. Study how people react to you and the camera. Sooner or later, someone will smile at you. Then you can approach.
- Permission granted, take quite a few pictures, as many as you feel you need of the subject. It bears repeating that you should talk while shooting. Your voice will prevent your subjects from being self-conscious and "freezing" into stiff poses. You will know when you've got the "right" shot.
- Don't be afraid of exploiting anyone. You are not hurting them by taking pictures. People will always let you know if they don't want to be photographed, or when they have had enough. Then they will tell or signal you to stop. So stop, of course, with a polite "thank you" in their language or in pantomime.
- Get physically close to people, especially if you have a responsive subject. If you approach someone slowly and keep talking, and *if you are comfortable being close*, then he or she will be okay about this too. I sometimes slowly work my way to within a couple of feet of my chosen "models," moving forward gradually with the camera never leaving my eye (again, shooting while talking all the time).
- Finally: Always, always ask a parent's permission before photographing children. And personally I find pictures of poor, ragged children anywhere to be exploitive.

PEOPLE IN A LOCATION

"Location portraits" include surroundings relevant to the subject, and are not frame-filling close-ups of faces. I love to photograph people in this way, choosing 20 and 28mm lenses with 35mm film cameras, or equivalent 14mm and 20mm lenses on my Fuji S-2 digital camera. (Like most 35mm digital SLRs currently in production, it magnifies the lens focal length by 1.4.) Wide-angle lenses have great inherent depth of field, so with them, it is usually possible to keep both person and background in focus. While with all wide-angle lenses there is always distortion at the edges of a picture, if you keep your subjects in the central 2/3 of the frame, distortion is hardly noticeable.

❶ Fish market, Bergen, Norway. I hung about watching the scene on an overcast day. The warm colors popped out; the fishmonger and I had no common language but we communicated with gestures. He was friendly, though this half-smile was the best I could get on one roll of film. Exposure was 1/60 a f/2.8 with a 20mm lens and 64 ISO film.

❷ Churchgoer, Moorea, French Polynesia. I arrived early to meet the worshippers. My portrait was made with a carefully leveled, handheld F-100 camera. Notice that the church is not distorted, that the lady is rendered large in relation to the background, and that the 20mm lens gives great depth of field—all reasons that I love wide-angle lenses. With 50 ISO film, exposure in open shade was 1/125 at f/8.

❸ A Polish folk artist. The artist and her canvases of scenes remembered from childhood were photographed in her Warsaw apartment. The room was lit by a big window at left. I arranged her work around her, and with a Nikon F-2 camera and 20mm lens on a tripod shot more than two rolls of film. I think I captured both the woman's fragility and her strength. Exposure with 64 ISO film was 1/30 at f/5.6, and I bracketed.

❹ Boy at the Hong Kong Dragon Boat Festival. The 20mm lens renders the whole scene sharp.

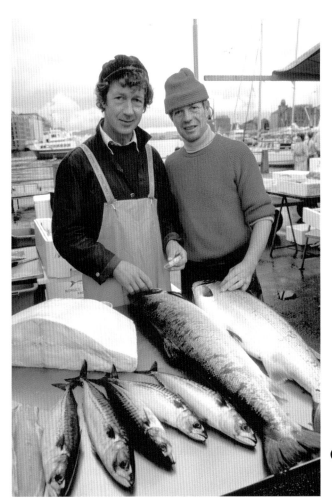

❶

❷

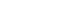

PEOPLE IN GROUPS

I don't think one can ever have too many people pictures in travel coverage. Groups can be found everywhere, caught unawares, arranged casually or formally posed.

❶ A delegation of young girls came to welcome tourists from a cruise ship to Dalien, China. F-3 camera and 20mm lens, 100 ISO film. Exposure was not recorded.

❷ An amateur cricket team in Kent, England, willingly arranged themselves in traditional team style after the game. 64 ISO film, 20mm lens. Exposure was 1/125 at f/5.6 on a cloudy day.

❸ I attended three church services one Sunday in Savannah la Mar, Jamaica, and got pictures of all three friendly congregations. Open shade, 100 ISO digital setting, 1/250 at f/8.

❹ Norwegian girls in local dress, Hardangerfjord. The girls were performing traditional dances in a hotel, but were happy to go outside and pose among the apple blossoms. I sent them pictures.

❺ Penitents in the ancient (and infamous) costumes of the Spanish Inquisition on parade during Holy Week in Seville, Spain. 400 ISO film, 80mm f/1.8 lens. Exposure was 1/30 at f/1.8.

❶

❷

❸

❹

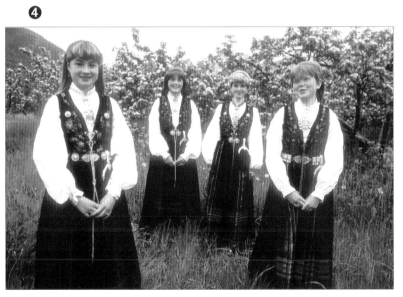

❺

GETTING CLOSE TO STRANGERS

I spotted this handicraft display next to the highway near Oaxaca, Mexico. I bought a yellow truck for less than $3, all the while talking to the truck's maker in my bad Spanish. After asking permission, I made a total of about thirty digital pictures of the scene. (I had a fluent Spanish-speaking driver, who helped a lot with communication also.)

❶ The first shot I make is often timid. Here I was distant and the background was messy.

❷ I knelt to get a close-up of the trucks; the background was still messy.

❸ By moving closer and to my left I put red trucks instead of green ones in the foreground; this shot is better.

❹ The man, now used to me, approached. I asked him to hold the big red truck and stood about four feet from him, then three. This made him look powerful, and eliminated the mess.

❺ Looking through the viewfinder and talking all the while, I gestured to the man to move slightly to the right and to hold the truck higher. I then bent to a slightly lower angle, which placed his head against the sky. The distracting bridge and strong converging lines in the background were now hidden and the big truck's wheel was separated from the small toy on the ground. I could have gone on shooting, but felt satisfied I had what I wanted, and bought another small truck as a thank-you. All pictures were made with my S-2 digital camera set to 100 ISO, with a 200mm lens. Exposure was 1/250 at f/8.

❶

❷

❸

❹

❺

Landscapes and Scenery

When in his nineties, the late great Edward Weston photographed a young tree on his Connecticut property in spring, summer, fall, and winter, in every imaginable kind of light and weather. The pictures are wonderful, and so simple. Scenery and landscape photography is about light, season, and weather just as much as it is about mountains, waterfalls, rocks, and beaches. A great exercise is to keep shooting a favorite spot that's easily accessible, just as Weston did. You may be surprised at what you will have at the end of a year. Landscape and scenic pictures can be shot in black-and-white or color, as preferred.

If you want to make panoramic views and don't have a panoramic camera, make overlapping shots. Print them and mount them separately or cut to fit, as you wish. Alternately, with the aid of a computer program, "stitch" digital or scanned film images together and retouch them so they appear seamless. Many digital printers accept long rolls of paper and are ideal for printing panoramas.

A few tips: Avoid extremely contrasty light. Meter off the sky, not off the sun itself, when photographing sunrises and sunsets. Bracket (vary) landscape exposures by about half and even one stop from "normal" in each direction, to vary the mood. Meter off gray rocks or any mid-toned subject when photographing snow, and bracket those exposures too. Vary your point of view with different lenses and different angles. Don't forget to shoot some close-ups of landscape features and vegetation. It's okay to include small, interesting buildings, distant roads, etc., in a scene if you wish, but avoid showing power lines, wind farms, and oil and gas pipelines if you want a peaceful effect. However, such shots might make useful stock images for textbooks.

Cities, Towns, and Villages

London was where I spent my teens, and I've lived in midtown Manhattan for almost all of my adult life. I love the energy and culture and mixture of people and the sheer stimulation of the world's biggest cities. You can often avoid showing snarled city traffic if you shoot before the morning rush hour, or after most office workers have gone home. Graffiti, overflowing garbage cans, or construction debris in cities are less obvious when you shoot in low, angled light.

I also like to photograph old provincial towns and small villages. I spent my young childhood in Littlewick Green, England, and I've owned a house in the hamlet of Wallkill in upstate New York for many years. My experience, though, is that even the most beautiful of such places can look a bit drab or unkempt in the brightest light of day. Early and late light and twilight are much kinder.

Tips: Shoot city skylines from high, not-too-distant vantage points with telephoto zoom lenses. This will permit you to frame your composition precisely. A good tripod makes it easy to keep horizontal and vertical lines level. A tripod will also allow you to shoot from sunset through "blue time" (twilight), adjusting your exposure as the light level falls. Starting just after sunset the sky will change from warm afterglow to pale then deep shades of blue, and finally to black. I like Ektachrome films for evening and night shooting; they hold excellent blues and blacks. Christmas is a good time to visit cities; in Christian countries there are decorations, of course, and in winter shooting at twilight lets

you capture lighted office buildings against a deep-blue sky. If you have a great vantage point within a city, composing with a wide-angle lens can produce fine results.

I always try to visit a place when a colorful local event is scheduled. In New York or Paris or Hong Kong these can be either world-class or more local street fairs or religious processions. In small towns and villages, market days, village fêtes, local sports days, rodeos, and Firemans' Fairs all make good subjects, with plenty of relaxed people around too.

Most places celebrate something with a fireworks display on occasion. To shoot fireworks, try to choose a vantage point so that buildings or landscape features are visible behind the fireworks. You will need a tripod and to set long exposures. You can't meter fireworks, but I have luck with 100 ISO film or 100 ISO digital camera settings, and use a f/5.6 aperture. I then vary shutter speeds between 4 and 30 seconds; the brightness of the bursts can vary considerably.

Of course, coverage of cities, towns, and villages is not complete without pictures of their inhabitants. People pictures bring life to almost any story. Go to shopping streets, markets, and parks to find them in receptive moods.

Buildings and Interiors

As with cityscapes, low early and late sunlight is best for delineating building exteriors and architectural details, but the season is also a factor. The front of north-facing buildings get sunlight only in high summer, at other times they may best be photographed on a cloudy day when light is virtually directionless. I may use long zoom lenses or wide-angles to photograph buildings, depending on how much space is around them and the available vantage points. I use a tripod to keep vertical and horizontal lines level. I try to include trees, gardens if those are important, and to photograph a building at twilight with some lights on inside, if that is possible. I'm also fond of photographing people close-up in front of a building if they are connected with the structure. For this, wide-angle lenses are unsurpassed because of their great depth of field. The parish priest in front of his church, a lord or duke in front of his stately home, innkeeper and inn—you get the idea.

Reciprocity Failure

With long exposures (short ones need not concern us here) be aware of the physical "Law of Reciprocity." *This law of light states that at very long (or extremely short) exposures, doubling the time of an exposure does not double the amount of light reaching the film or digital capture card.* You must add more time to record extremely long exposures accurately. If I shoot a twilight scene where the meter aimed at deep-blue sky indicates an exposure of 4 seconds at f/5.6, for instance, I will also expose at 6, 8, 10, and maybe even 20 seconds. There will be surprisingly little difference in the results, but one image will normally be better than the others. The mood in each shot will be different, too.

LANDSCAPE AND CITYSCAPE BASICS

Often, the key to a fine view is finding a good vantage point. This can involve driving, hiking, and even climbing high or lying on the ground. A moderate telephoto or zoom lens can often be useful; so can a good tripod.

❶ I rarely shoot anything under bright overhead sun, but in mid-September fast-moving clouds cast interesting shadows on a historic terraced garden in Kauai, Hawaii, giving the scene texture and depth. I used a hand-held Nikon F-100, 20mm lens, and 50 ISO film. Exposure was 1/60 at f/11 with point of focus one-third of the way into the scene. As there were no straight lines to distort, I tilted the lens slightly forward. Both are techniques that maximize depth of field.

❷ Skies are always important in landscapes, and clouds make all the difference in skies, whether in daylight or here, at sunset in the Joshua Tree National Park, CA. I used a Nikon N-90 camera, 50 ISO Fuji Velvia film and an 80-200mm f/2.8 lens with camera mounted on a tripod. I bracketed exposures around 1/60 at f/5.6.

❸ If the sky is dull, compose to cut all or most of it out of your scene. Here I concentrated on the beautiful plants in the famous Garden of the Humble Administrator in Souzhou, China. I lay on the ground handholding an F-3 camera so the 20mm lens hung over the water. Eliminating the front edge of the pond made it and the foreground plants appear larger. Exposure on a heavily overcast day with 100 ISO film was 1/60 at f/4.

❹ The shot of washing was made in Singapore, but could also stand for Hong Kong, Naples, and many other close-packed cities too.

❺ Switzerland. Village of Ftan in the Romansch-speaking area near St. Moritz. Here I used a 28–80mm zoom lens to make the Dolomite mountains appear closer.

❻ Here, I've symbolized bustling Tokyo by mounting my camera on a tripod while zooming in on the brightly lit buildings.

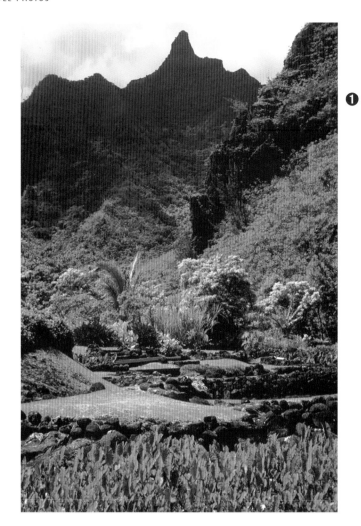

❶

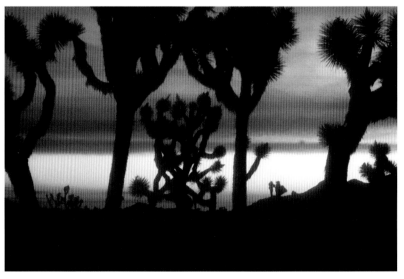

❷

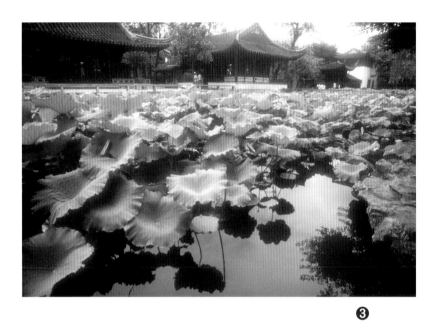

❸

❺

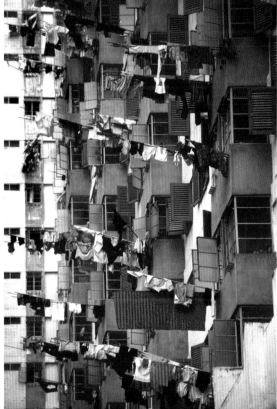

❹

❻

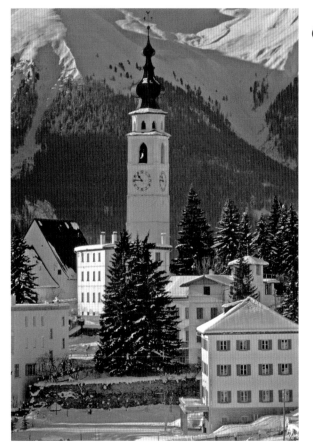

SCULPTURE

As a rule, sculpture, decorations on buildings, etc., are best photographed with "sidelighting"—sun (or artificial light) aimed from low on one side onto a subject. This type of light reveals maximum texture.

❶ Totem pole, Stanley Park, Victoria, B.C., Canada. I stood back with an 80–200mm zoom lens to fill the frame with the head, about twenty-five feet above the ground. Bright paint compensated for the heavily overcast, therefore flat, light. 50 ISO film; 1/250 at f/4.

❷ Sculpture of woman, Angkor Wat, Kampuchea (formerly Cambodia). F-2 camera, 20mm lens, 64 ISO film. I spent a wonderful afternoon wandering alone by the mysterious temple decorations. Here the afternoon sun was low enough to reveal the maximum texture of the exotic (or erotic) relief figure, who seems to be a dancer.

❸ Roman ruins, Ephesus, Turkey. 43–80mm lens; 100 ISO film. Exposure was 1/25 at f/8.

❹ Buddhist temple, Taipei, Taiwan. This stunning building was backlit by low evening sun shining almost directly into the lens. The circular "flare" was caused by the sun hitting and bouncing off the internal elements of my 20mm lens. Great care must always be taken when trying for flare effects. Try changing angles to the sun and using your camera's Stop Down Preview button—if it has one—to previsualize effects (see camera manuals). Here, exposure on ISO film was 1/60 at f/5.6. The color here was dull, slightly degraded by the flare, so I later "tweaked" the scanned image, upping the contrast and brightening the color with Adobe Photoshop.

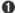 ❶

❷

❸

❹

In Europe especially, many historic buildings are floodlit. Shooting floodlighting and "Sound and Light" shows requires long exposures, and thus a tripod. I meter off mid-toned areas using a telephoto lens with the camera set to spot-metering mode. Or, I can use a handheld, narrow angle "spot meter." Because floodlighting and other night subjects are often contrasty, I bracket such exposures, varying both apertures and shutter speeds.

The Natural World

One of the many things I love about being a travel photographer is that I'm not a specialist. I've now had several opportunities to photograph wildlife in remote areas of the world and these assignments have opened up new possibilities for my essentially citified life. I've pursued all chances possible to shoot in the great outdoors ever since I went on my first big nature shoot—it was for a tourism brochure promoting East African wildlife safaris, and that assignment is still a highlight of my travel experiences. I traveled to Africa with my fiancé, who was a photographer and expert mechanic and who acted as assistant and driver on the trip. We were in love and spent three weeks driving in a Land Rover specially modified for filming or still photography. We toured the top national parks of Kenya and Tanzania with the help of a map, list of lodges, and a tentative itinerary. We were alone, except for hiring a guide for one day, to find giraffes in the Serengeti (he did; you can see a few of our pictures here). We also spent many hours photographing and admiring lions, elephants, zebra, wildebeests, hippos, and more in their beautiful natural habitats.

Caution: It is safer not to travel alone in East Africa today, but many good tour operators exist. These guarantee no more that six people to one vehicle, so all have unobstructed views. Find safari operators on the Web, as my friends Lucia Pitter and Ricardo De Mattos recently did (they loved Tanzania in the summer of 2003).

For my own big safari assignment, I took a 500mm f/8 mirror telephoto, an 80–200mm f/4 zoom, a 50mm macro, and 28mm and 20mm f/2.8 wide-angles, plus a Gitzo tripod that was eye-level height for me. Now my favorite long lenses are a superb 300mm f/2.8 Tamron and a lightweight, sharp 70-300mm f/4–f/5.6 Nikkor zoom. I also work with an 80mm macro Nikkor lens when shooting insects, flowers, and extreme close-ups of any kind. All are autofocus lenses. If birds are my intended subject I carry a compact, lightweight "tele-extender." This gives a true increase in lens focal length that will increase the size of a distant subject by a factor of 1.4× or 2×. The extenders cost one f/stop or two f/stops in exposure respectively. When using long lenses I always mount the camera on a tripod. This not only saves my arms from aching—there's a lot of waiting around for most types of nature photography—it also minimizes the possibility of blurred pictures caused by camera shake.

I've photographed in the Galapagos, Alaska, many U.S. national parks, and wildlife refuges. I live in a city, so in between big shoots, I keep my reflexes sharp for fast-moving creatures by visiting the Bronx Zoo and the Jamaica Bay National Wildlife Refuge, both here in New York City.

Local Events, National Passions, and Sports

Outdoor sports you may encounter on your travels may include marathons and rodeos, or baseball, soccer, and football games, from international soccer to the Little League level. Surfing, windsurfing, and parasailing, diving, and snorkeling can now all be found at seaside destinations and islands, and sporting challenges at county, state, and village fairs in many countries may include tests of strength of all kinds. I love to photograph rodeos, horse shows, and horse racing, all national pastimes. I can't say I love bullfighting, but it is part of the life of Spain, Mexico, and several other countries and does have moments of beauty as well as cruelty.

I approach sports with the same equipment as I do wildlife photography, and also hope that my reflexes are sharp so I can anticipate and capture peak moments of action. Many professional sports photographers use a "monopod" to prevent long-lens shake, causing blurred pictures. (A monopod has one collapsible leg that can be locked to eye-level height.) The camera attaches on top, of course, and the photographer won't trip people up in crowds. I usually just fold the legs of my tripod together, to make a one-legged tripod when shooting with long lenses in crowds; that way, I can move around easily, but spread the tripod legs if space opens up.

A few tips for shooting big events: Get to the location early—hours early is probably not too soon. Then the place will be uncrowded and you can often talk your way into good vantage points that only VIPs and the press will have access to later. The unobtrusive offer of a moderate-size banknote may help too, but be careful about this—make sure a person you give money to can actually get you in.

If you are alone, it is often possible to buy one ticket at face value at the last minute for sold-out rock concerts, World Series games, and the like, sold by someone whose partner couldn't make it. To deal or not to deal with scalpers is your own decision, of course.

If you are patient and wait until late, some folks don't stay to the end of a long event, and may be talked into giving you their ticket stub so you can seemingly re-enter. Also, you might then be able to get in through side doors or barricades opened up to permit people to leave.

Caution: You risk being evicted or even having your film taken away or digital cards erased if you shoot at indoor events where photography is forbidden. This is especially true at rock concerts. I have occasionally "sneaked" pictures at noisy moments during opera performances and musicals in London and New York. I'm quick and careful about it, and never, ever use flash. It's not too hard to get pictures of final curtain calls anywhere, because a lot of people besides you will be doing this.

If, despite your best efforts, you can't get into a major event, don't despair. Signs for the big game or performance and even exterior stadium views will provide background coverage, and the crowds surrounding big events are often colorful, noisy, and pictures of them can convey the spirit of what's going on inside. I love fanatic fans, who often dress up for their team or favorite band. These guys and girls (and older men and women too) are usually thrilled to pose.

And if the big event is completely sold out, you may be able to find something else that more than compensates for it. Look at local newspapers on arrival for listings of things happening while you are there. Local events are usually fun, easy to access, and present great opportunities for photographing

TIPS FOR PHOTOGRAPHING ON SAFARI

When shooting wildlife, work with two cameras if possible, also carry extra batteries, film, or spare digital media cards—you don't want to lose great moments while changing film, media, or lenses. Telephoto and wide-angle lenses can both be useful.

❶ Working in Tsavo West National Park, Kenya, from a Land Rover, I used a tripod-mounted Nikon F-2 and an 80–200mm lens, and shot about one hundred pictures of this group of elephants before they left the area. Exposures were 1/250 at f/4–f/4.5 or f/5.6 on a gray day.

❷ A young lion in a tree in the vicinity of Lake Manyara, Tanzania, was photographed with a handheld 80–200mm lens on a Nikon F-2 camera. I used 64 ISO film. Exposure and lens extension were not recorded but we were quite close!

❸ A waterhole viewed from the terrace of Kilaguni Lodge, Tsavo West National Park, Kenya. A tripod-mounted F-2 and 80–200mm lens were used to record the zebras and reflections in late-afternoon sun. Exposure with 64 ISO film was 1/250 at f/8.

❹ Lion in Ngorongoro Crater National Park, Tanzania. We were close enough for me to capture his image with a 20mm lens. Exposure on 64 ISO film was 1/250 at f/5.6.

❺ Giraffe at Sunset, Tanzania. This is not a photomontage but a single image. I made it from a Land Rover fitted for photography and filming. It had an open roof and a shooting platform. I used 64 ISO film and 500mm f/8 mirror telephoto lens. The camera was on a tripod and my driver moved the vehicle slowly to keep us between the giraffe and the sun. I metered off the sky, but do not remember the precise shutter speed.

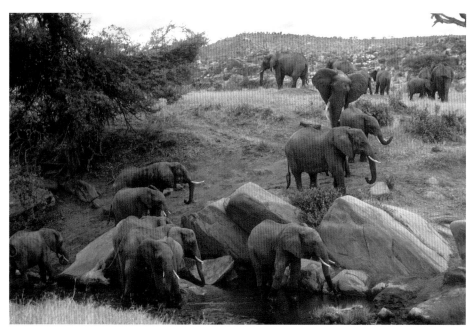

❶

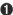

❷

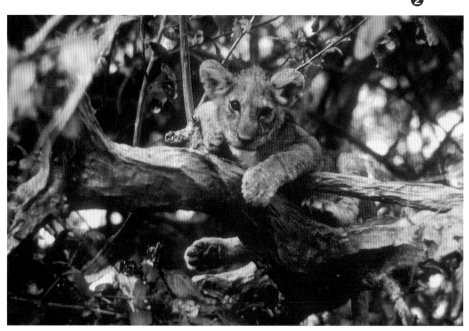

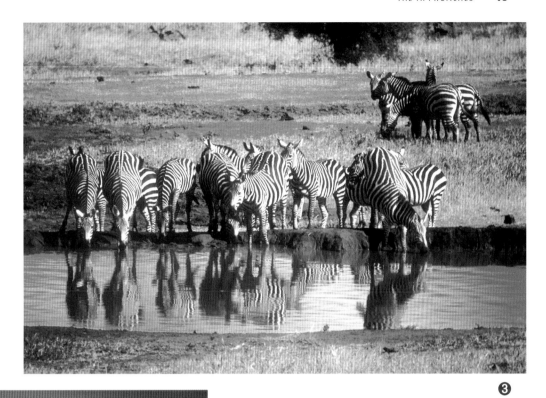

❸

❺

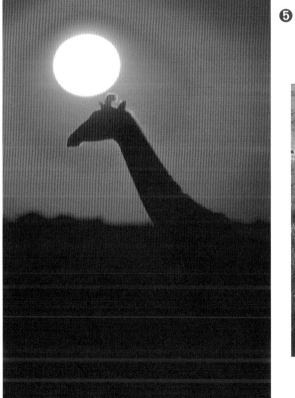

❹

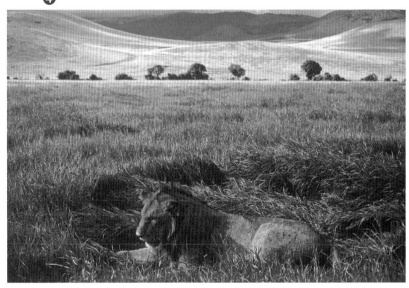

LANDSCAPES WITH ANIMALS

Domestic animals add interest to landscapes just as wild ones do. Avoid centering animals in a scene unless you have a deliberate reason to do this. Learn how to hold focus and "reframe" if needed.

❶ The Mountains of Mourne, in Northern Ireland, are low but beautiful. Using a 20mm lens two feet from the cow in front exaggerated its size. Late-afternoon sun shone intermittently through fast-moving clouds that cast shadows on different parts of the scene; I was lucky when the foreground beast moved so that her eye was illuminated for a moment. With 64 ISO film exposure was 1/60 at f/11. I focused one-third into the scene to maximize depth of field.

❷ Landscape with a donkey, near Bethlehem, Israel. Warm late-afternoon sun, 64 ISO film, 1/250 at f/11. I used a telephoto zoom lens, but did not record which one.

❸ Landscape with cows, Normandy, France. S-2 digital camera, 70–30mm lens, 100 ISO setting, 1/500 at f/5.6.

❹ Landscape with cowherd at sunset, Bali, Indonesia. I was in position to shoot a sunset when man and beast walked into my frame. I got just one shot, using a 500mm f/8 mirror telephoto lens, camera on tripod. Exposure was 1/30 at f/8.

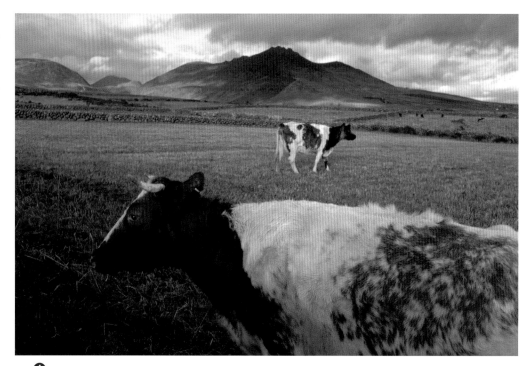

❶

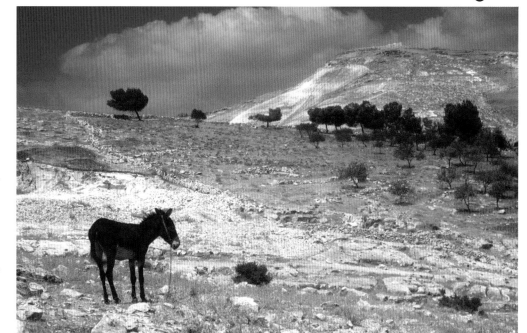

❷

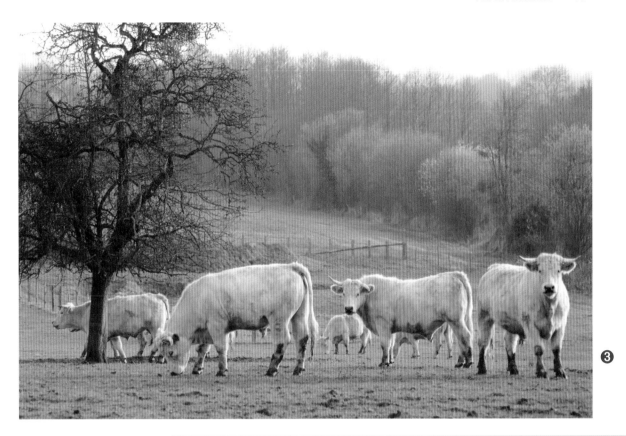

❸

❹

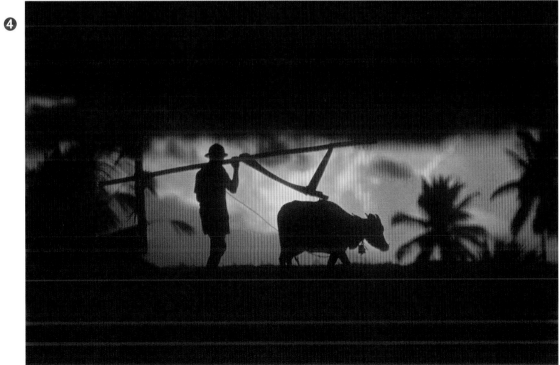

PHOTOGRAPHING BIRDS AND OTHER WILDLIFE

There are plenty of places to find animals in the wild in western North America, in national parks especially. In the eastern United States, Canada, and Europe, and other places, it may be hard to spot big wildlife other than deer, but you can practice animal photography almost anywhere in a good zoo. Many zoos are well designed, and it's possible to eliminate bars and fences if you frame carefully and shoot with wide f/stops to minimize background intrusion. Birds are also to be found everywhere; big seabirds are relatively easy to photograph, while smaller birds are the hardest.

❶ A male frigate bird displays his red throat to attract a mate, Tower Island, Galapagos, Ecuador. As more visitors come to the islands, the birds retreat further and further from popular trails. I made this shot from a marked trail with a Nikon FM-2, and a 400mm f/5.6 Tokina lens plus a 1.4x tele-extender device. This made the lens an effective 560mm f/8. With 200 ISO film, exposure was 1/500 at f/8.

❷ Koala mother and baby, Healesville Wildlife Sanctuary, Victoria, Australia. When shooting in zoos I try to make the scene look as natural as possible by composing to eliminate bars, wire mesh, etc. With 100 ISO film, a Nikon FM-2 camera, 80–300mm zoom lens, and an on-camera Nikon SB-26 TTL flash activated, this picture was exposed at 1/125 at f/5.6.

❸ Brown bear, Katmai National Park, Alaska. I waited for most of three days to get a good bear sighting in August (which is outside of the main salmon-run/bear-feeding season). But this young guy didn't know the fish were mostly gone. I was on an official park viewing/shooting platform about fifteen feet high, and maybe forty feet from the bear, and used 50 ISO film and a 300mm f/2.8 telephoto lens, on a tripod. Exposure was 1/250 at f/8. Bears run surprisingly fast; I got in just three exposures before this one disappeared.

❹ Farne Islands, U.K. This wildlife sanctuary is a half-hour boat ride from England's northeast coast. During the peak breeding season, it's easy to get close to thousands of Atlantic puffins and other seabirds. Here I used a tripod-mounted 80–200mm lens at full extension.

❺ Two pandas, National Zoo, Washington, D.C. Pandas tend to sleep most of the time, but here, after waiting for almost an hour for some action, I got lucky. Tripod-mounted S-1 digital camera, 70–300mm f/4–f/5.6 zoom lens. At 400 ISO, exposure was 1/250 at f/11.

❻ Peacock. These birds are revered in India and Pakistan and are to be seen all over. But, despite my three visits to the subcontinent, I never was able to get near one putting on his proud mating display. However, one spring day in New York's Bronx Zoo this guy posed for me like a star. I remember I used a 300mm lens handheld.

❶

❷

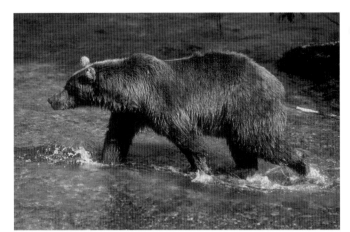

❸

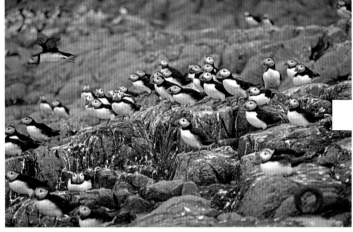

❹

❺

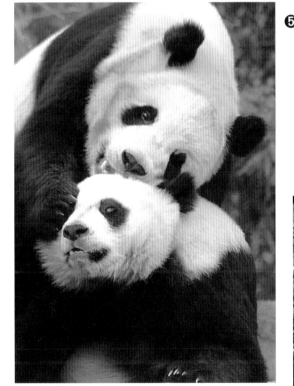

❻

HOTELS AND MORE

If you shoot for travel or tourism clients, or would like to, you will certainly have to cover hotels and their amenities: staff, food, pool, etc. Sometimes clients must be included, and if you get to the top level, professional models, or even celebrities might be involved. To build a portfolio you can shoot in restaurants, pubs, clubs, and more but do remember that you must ask permission and get model releases if you intend any of the images for commercial use. Hotel staff, etc., always appreciate tips as well as thank-you prints.

Pictures 1–5 in this series were made at the Sea Splash Resort in Negril, Jamaica. I shot with my Fuji S-2 digital camera, mostly set to Manual mode and used 14mm, 20mm, 35–80mm, and 70–200mm lenses, as needed.

❶ This charming server at Sea Splash was photographed in the outdoor restaurant, shaded by a roof, with daylight coming from the left. With a 20mm lens and 400 ISO setting, I positioned myself and her so that natural light was sufficient. Exposure was 1/60 at f/4.

❷ The bar at Sea Splash Resort. Fuji S-2 digital camera, 14mm lens, 800 ISO setting. I metered off the barman and carefully leveled the handheld camera.

❸ With a 14mm lens on my S-2 digital camera (the equivalent of a 20mm lens on a 35mm film camera), I carefully leveled and held it so the front edge of the pool didn't show. I asked a guest to dive while her mother looked on. Exposure at 100 ISO setting was 1/500 at f/8 in mid-afternoon.

❹ I waded out waist-deep to capture Sea Splash's pretty restaurant from the water. I set the camera to 1600 ISO and Program mode, with a 20mm f/2.8 lens, and let the camera change apertures and shutter speeds as the twilight deepened. Neither the lightest nor the darkest exposure that I made, this shot nicely balanced indoor and outdoor light.

❺ A food shot made in shaded natural light. I used a 20mm lens, before eating my tropical breakfast. Exposure at a 400 ISO digital setting was 1/60 at f/5.6 with a 28mm lens.

❻ Mural, Pioneer Hotel, Lahaina, Maui. This mural decorates the bar and the photo was made in low light with my digital camera set to 400 ISO.

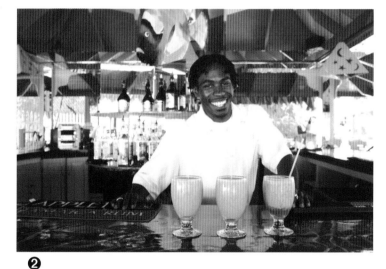

❹

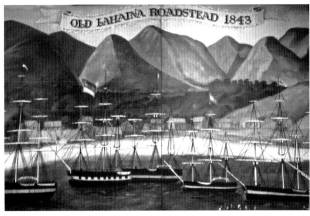

❻

❺

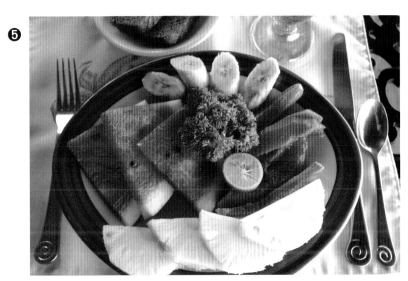

PUBS, CLUBS, AND ENTERTAINMENT

Today it's okay to shoot handheld indoors and even to show blur; do this if you don't need color-accurate food. Then, you must be able to use flash off-camera competently, or may even need to set up powerful strobe lights. If you must do either, get permission in advance. Shortly before a meal service is the optimum time to shoot posed restaurant "formals," and you must get in and out fast!

❶ Pub interior, Richmond, London, U.K. I "sneaked" this picture by setting my F-100 camera and 20mm lens on my table. I relied on the camera's manual focus set for 10 feet. Exposure with 400 ISO film was set by the camera's Aperture Priority mode at f/5.6, which chose a slow shutter speed.

❷ Pub barmaid, London, U.K. I shot with her permission. F-100 camera, 400 ISO film, 28mm lens, exposure 1/60 at f/2.8.

❸ A wide-angle lens is an essential for photographing big interiors. Here, I used a 14mm f/2.8 lens on my digital camera (the equivalent to a 20mm lens on a 35mm SLR). I shot the Queen's Room on the *Queen Mary II* by existing light with a Fuji S-2 rated at 400 ISO with camera on a tripod so I could carefully level the scene. Manual exposure was not recorded.

❹ Outdoor café, Oaxaca, Mexico. My S-2 camera was mounted on a tripod, and I used my favorite 20mm lens. Exposure at a 400 ISO setting was 1/60 at f/4.

❺ Hotel buffet with ice sculpture. One of many food shots I have done for tourism clients. My tripod-mounted F-3 camera was used with a 28mm lens and 64 ISO film. Lighting was a portable professional strobe unit, exposure set with a flash-meter reading. (For more on using professional flash and strobes, see my books *Photo Lighting Simplified* and/or *Mastering Flash Photography*.)

❻ Birdland, New York City. You may photograph musicians at this famous jazz club without a tripod or a flash. I set 1600 ISO on my S-2 digital camera and took about one hundred shots with my 70–300mm lens at f/4 or f/5.6, shutter speeds of between 1/10 and 1/30 of a second, and different lens extensions. Of this number, I liked about ten shots.

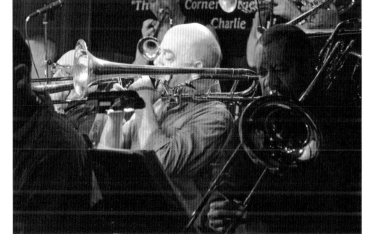

people, and even for getting to know some of the "natives." Local happenings provide a window into the life of a state or village or country, and liven up just about any travel story. Agricultural shows in France, county fairs in the United States, and horse shows in England, local saint's days in Italy and Spain, cricket matches in the West Indies, dragon boat races in many places in Asia are just a few of the many possibilities.

Restaurants, Hotels, Resorts, Cruises, and Tours

To photograph all of these, you need cooperation from the hardworking and not especially highly paid staff who keep the operations running smoothly. Be very, very nice to such folk. The best expression of appreciation for their unstinting help is usually a big, fat tip (but do not tip managers, ship's officers, executive chefs, and owners, of course). Again, your "people skills" and powers of persuasion will be invaluable in getting what you want. At all of the above tourist facilities, I like to use actual guests or clients as models if possible—staff can be used, too, in an emergency, but they don't usually have the right clothes or "look" to be convincing guests. If you are photographing guests, remember they are paying for this vacation, and work as quickly as possible. They might enjoy letting you photograph them playing golf, or shooting skeet, or drinking wine while gazing into each others' eyes, but not if it takes more than about twenty minutes or so.

To use any pictures for tourism or travel promotion requires that each person that you photograph signs a model release. For guests at tourist facilities, the release can cover promotional use by that facility only, and that's the way I go with most clients who may be important people not willing to sign a "blanket" release valid for any and all commercial or advertising uses. You do not need to get model releases if the images are for personal or fine art use, or for editorial publication inside books and magazines. However, model releases always makes pictures more valuable. Then they can be marketed as stock images, and offered for lease on personal and commercial Web sites. Most stock agencies today will not consider images that are not model released. Note that private property and pets must be released as well.

For sample editorial, limited, and commercial model releases, releases for minor children, and animal/property releases that you may copy and use, see page 119. My book *Travel Photography,* Second Edition, also contains model releases in twenty-nine different languages that you can copy and use. Also see *Legal Guide for the Visual Artist* by Tad Crawford.

Transportation

Buses, trains, subways, stations, ships harbors, bridges, and highways can all be interesting graphic subjects, as can planes and airports. Some or all of these may be difficult to photograph or even approach in the United States, especially when security concerns are high. When photographing such places, always obey any instructions from police, the army, or other authorities or you may be in big trouble. Caution: In many foreign countries, especially those with governments that are authoritarian or worse, my advice is not to risk even approaching highly sensitive places and subjects, includ-

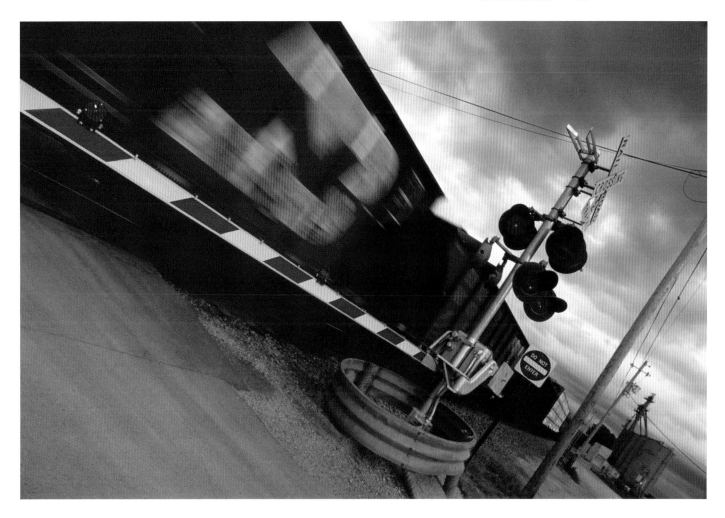

ing police on or off duty and military personnel. But here are some pictures to give you ideas, in case you can photograph transportation facilities in comfort and safety.

Icons and Symbols

There are certain subjects that are recognized around the world as symbolic of different countries, regions, and cities. These icons are used extensively in tourism brochures, and you should capture them for your files. They will come in handy for photo albums and slide shows, even for fine art exhibits if you are good at getting fresh slants on major clichés. Commercial travel photographers must have the best possible pictures of, for example, the Eiffel Tower and the Statue of Liberty as well as other top landmarks.

A few years ago, I went to Europe to shoot a brochure for a new travel client, a company that operated student tours. That summer, Big Ben, the Eiffel Tower, the Coliseum, and the Acropolis were all shrouded in scaffolding and heavy netting. My files saved the day.

Moving freight train, Illinois. My car was stopped at a barrier to let this fast freight pass and I made a lucky "grab" shot. Perhaps it wasn't all that lucky, because though I almost always shoot in Manual mode, I do keep my camera set to the prevailing light. Here a 20mm lens was on my camera and 100 ISO film was loaded. Exposure was 1/30 at f/8 on a heavily overcast day.

SHOOTING FROM PLANES, TRAINS, AUTOMOBILES ... AND BOATS TOO

It's worth photographing anything that appeals, even when you are in a fast-moving vehicle or storm-tossed boat. If you want sharp pictures, set a 1/500 of a second shutter speed, or higher, on your camera. If the light is poor, you will also need high-speed film or must set a high ISO speed on your digital camera. Or, shoot anyway and risk blur—you'll get some failures, but some blurred pictures convey a "travel" feel extremely well.

1 Katmai National Park, Alaska, from a floatplane.

2 Brown bear from a tour bus, Denali National Park, Alaska.

3 Festival, Oaxaca, Mexico, photographed from a moving car.

4 Canal barge, River Avon, U.K., from another barge.

5 Burgundy fields, France, from a balloon.

1

2

❸

❹

❺

ICONS AND SYMBOLS

Some structures are so famous that they represent a country as well as themselves. The Statue of Liberty, the Eiffel Tower, and Big Ben are just three examples. Here are a few views of famous sites that I've tried to make as non-cliché as possible.

❶ & ❷The Great Wall and the Pyramids are ancient world wonders that also symbolize modern China and Egypt. I used wide-angle lenses to include as much background as possible to show the settings.

❸ Christo Statue, the famous symbol of Rio de Janeiro, Brazil. Using a 100mm lens to bring the mountain closer, I shot from a low angle to throw some foreground grass out of focus.

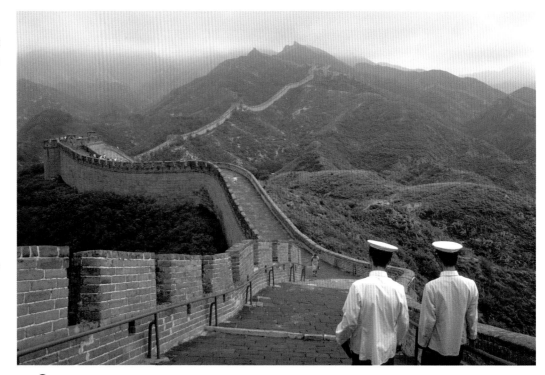

❶

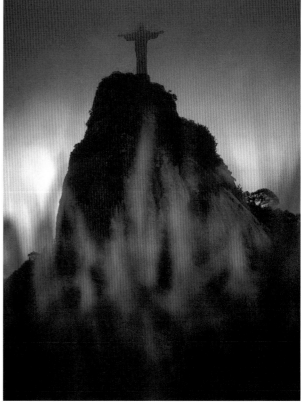

❸

❷

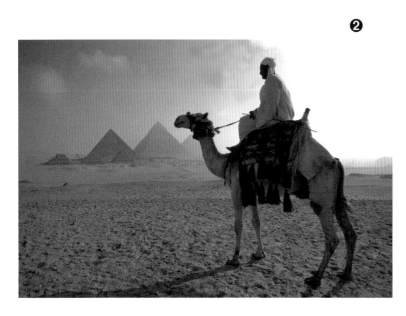

People can be symbols, too, especially if wearing costume or uniform. Everyone knows where the guys in red coats, dark riding britches, and flat brimmed khaki hats come from, or the ladies dressed in white bonnets, striped dresses, and wooden shoes. Try to get good pictures of guardsmen and spear-carrying tribesmen, guys in long flowered shorts with surfboards, or sombrero-wearing fellows in elaborately ruffled jackets and tight pants carrying musical instruments.

Interestingly, symbols can mean different things to different peoples. In the United States, Lady Liberty stands for New York City. To people in other lands, she stands for the entire United States. Also, symbols change. A jolly, helmeted London bobby was once a benign, popular symbol for Great Britain, but a recent rise in crime and the need for preventing international terrorist actions have made police there and everywhere have a much tougher image.

PEOPLE IN COSTUME

Sadly, in most places today, people don't wear traditional costumes anymore. But if you plan a visit that coincides with a national or religious holiday, saint's day, or local festival, or if you encounter ceremonial events like weddings, you'll often find such costumes worn with pride for the occasion. Approach people gently, smile, and ask permission before you shoot —that's my way, anyway. And don't forget that some folks pose in costume at tourist sites. A small donation to them will always get you a few pictures. Also, there are many colorful shows put on for tourists that include time for photography.

❶ Pilgrims visiting a holy site in Nikko, Japan. The Japanese seem to enjoy having their pictures taken. In exchange for this one, I let the men photograph me!

❷ Dollmaker, Belgrade, Serbia. On a magazine assignment, I was introduced to this well-known folk artist, and obviously did not tip her.

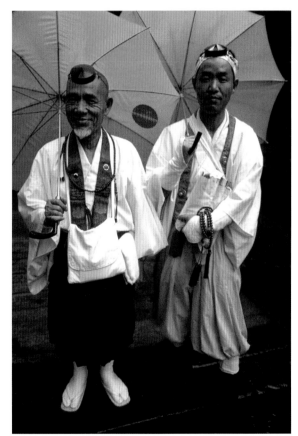

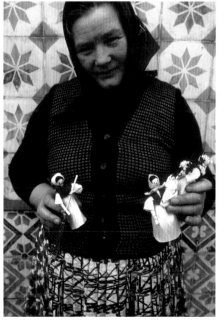
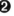

PEOPLE IN COSTUME
(continued)

❸ Man in a tribal costume posing in the Zocalo (central square), Mexico City, Mexico. As posing is his profession, he was pleased with my $2 tip.

❹ Souvenir seller, Chinatown, New York City, during Chinese New Year celebrations. This girl is elegant and she knew it, and was very willing to pose.

❺ Lantern Festival, Kyoto, Japan. I try to eliminate people wearing inappropriate eyeglasses, sneakers, or watches at such events!

❻ Masai Tribesmen, Kenya. This double portrait was made at a village dance and cultural show in Kenya. The price of a day's outing included this interesting stop.

❼ Malaysian wedding staged for tourists, Singapore. Mock weddings are included in many tourist shows, and the evening's fun usually includes dinner, drinks, music, and the opportunity to take pictures.

❽ Swiss Guards at the Vatican, Rome, Italy. With 50 ISO film in open shade, I set my 80mm f/1.8 lens at its widest aperture to throw the background guard out of focus. Exposure was 1/1000 at f/1.8.

❸

❹

❺

❻

❼

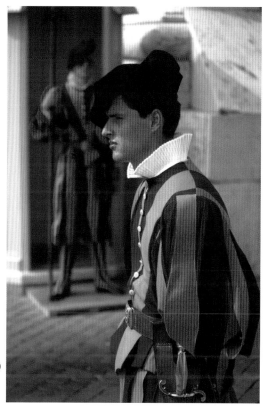

❽

En Route

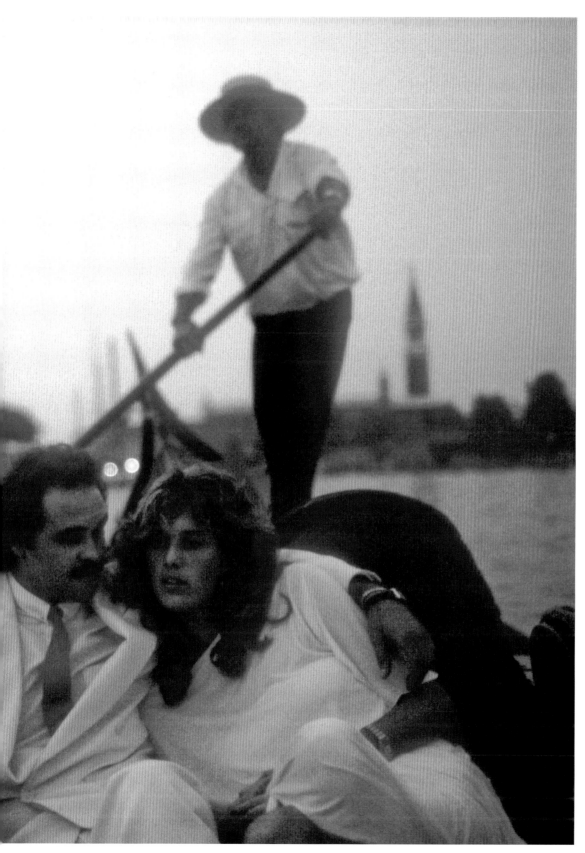

Painters and photographers have depicted storied Venice, Italy, for centuries. It's still so beautiful that even raw beginners can make great shots here (but do try to avoid overhead sun, crowds and clutter). For the more advanced, it's worth searching out new approaches. On a gondola with two models at twilight, I directed the gondolier with gestures to turn for the best visual angles using an N-90 camera, 20mm f/2,8 lens and 400 ISO Ektachrome film. Exposure was 1/30 with a 20mm f/2.8 lens, handheld.

When to Go

If your vacation time is restricted, or if you must consider a spouse or companion's job, or if the kids' holidays must be taken into account, or you have a job to shoot, the best time to travel is whenever possible or required. That's true for me too, but when I can choose the time of my visit, I like to go out of high season. Airfares and hotel prices fall sometimes considerably, major attractions and museums are less crowded, and you are more likely to meet locals at your destination.

I often go to London in mid-winter, for instance. I have a sister, her family, and dear friends there, but I also love to go to the theater, catch top art shows, and perhaps visit one or more marvelous stately homes or cathedrals. Winter scenery is especially lovely under snow, of course, but can be beautiful in the form of brown plowed fields and bare trees too. And though no one ever goes to England expecting to enjoy great weather, it can and does happen at any time of year. In December, January, and February, London is much milder than New York, and rain and snowfalls, if they occur, are almost never as severe as they are in the northern United States. (Of course, if you live in the southern states or in California, you don't need to travel to find fine weather, anyway.) The picture of the big wheel called the London Eye was made on January 1, 2001. The picture of the horse guards in snow, shown on pages 56–57, was made in late December.

Avoid monsoon season in India (it usually starts in September), but don't go just before the monsoon either, as I did one July—a scheduling mistake made by a client. Dehli and Jaipur and Varanasi on the Ganges were almost unbearably hot. My serious amateur photographer friend and travel enthusiast Pat Collyns, who lives in London and has been to India several times, says January is the perfect time to visit. Southern Asia in general is not pleasant in summer months. Avoid Hong Kong's summer months in particular; I've experienced heavy rains there on more than one visit. Japan is an exception: I've had lovely, crisp, almost fall-like weather with clear blue skies there in August. My Brazilian friends recommend November and December as great months to see Rio: people are excited about spring, and the beach-loving Cariocas come out of winter dullness to work on their tans. In fact, all of Latin America is great to visit in spring and fall; I've made six visits there in total, usually in April or August, and had near-perfect weather every time.

It doesn't really matter when you go to the Caribbean islands, although it's probably best to avoid the hurricane season, which officially occurs from September through October. I went to Jamaica in May 2003, one of the hottest, most humid months of their year. Mornings were clear; it did rain heavily on several, but not all, afternoons, then soon cleared up; and the sunsets were spectacular. Hotels are all air-conditioned and rates are big bargains in Jamaica's low season. You can say the same thing about most of the rest of the Caribbean. Hawaii has fantastic weather practically year-round; so do French Polynesia, tropical Australia, and Mexico.

Christmas decorations in New York City are spectacular, the theater season here is in full swing throughout the winter, and we do get plenty of winter sun. Avoid January through mud season in most of the northern U.S. states, except at winter sports resorts, of course. (I hate the combination of damp and cold). Summer residents start re-appearing in New York State and New England in late April or early May.

Read guidebooks, go to official Tourist Office Web sites and read travel magazines and newspaper travel supplements to learn more about worldwide climate and weather conditions. Also read

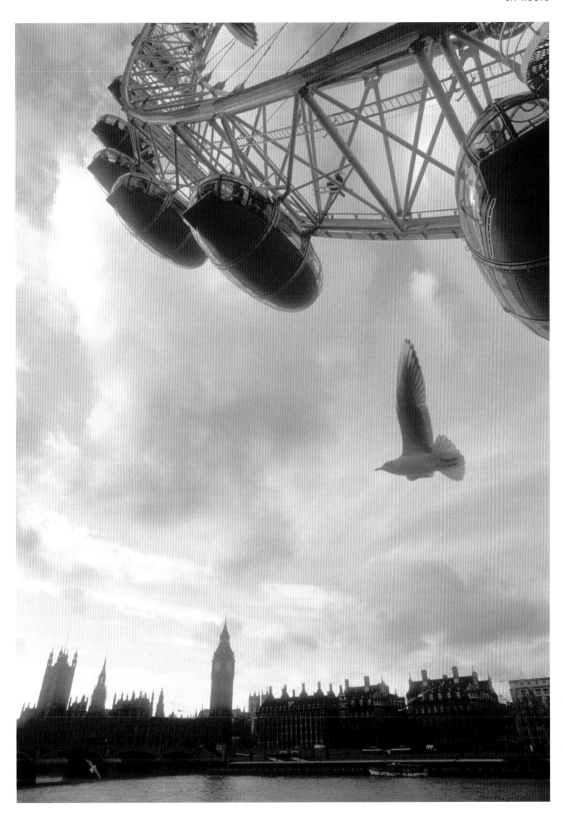

The London Eye and Big Ben, U.K. 200 ISO Agfa Scala black-and-white slide film, Nikon F-100 camera, 20mm lens. Exposure on a cloudy day was 1/125 at f/8.

WHERE TO FIND GREAT PICTURES: LATIN AMERICA

I've been to all but three South American countries, and hope to visit Bolivia and Uruguay soon. I'm giving Colombia a miss at present.

❶ The Galapagos Islands are one of the great nature-photography experiences (see photos on pages 39 and 78) but are visited more and more by tourists. Consider going there off-season. When in Ecuador, also visit the great Otavalo market, famous for weavings. I photographed these women there after buying a rug. 28mm lens, 50 ISO film, 1/1250 at f/8.

❷ This ranch hand in the mountains of El Salvador was wearing beige, and the landscape was a similar shade. I transposed the image to black-and-white. Exposure was by meter, on 100 ISO film, with a short telephoto lens.

❸ Old man with herbs, Ouro Preto, Brazil.

❹ Restaurant, Buenos Aires, Argentina. This highly sophisticated city is often called the Paris (or the London) of South America. I photographed in the Italian-flavored La Boca neighborhood with the permission of the owners, using 400 ISO film rated at 800 ISO. My F-3 camera was handheld with an 80mm f/1.8 lens. I forget the aperture and shutter speed chosen.

❶

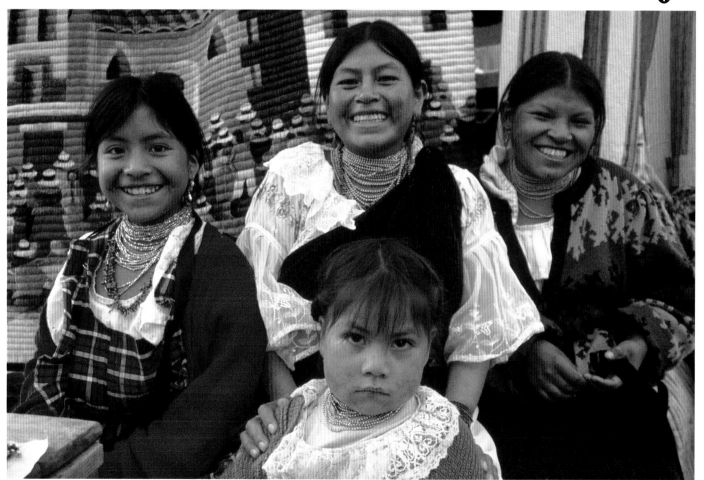

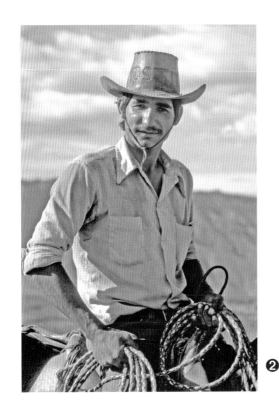

❷

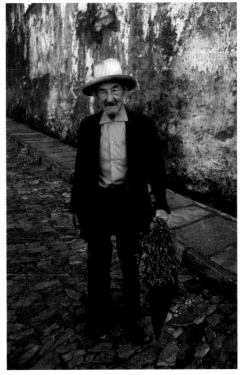

❸

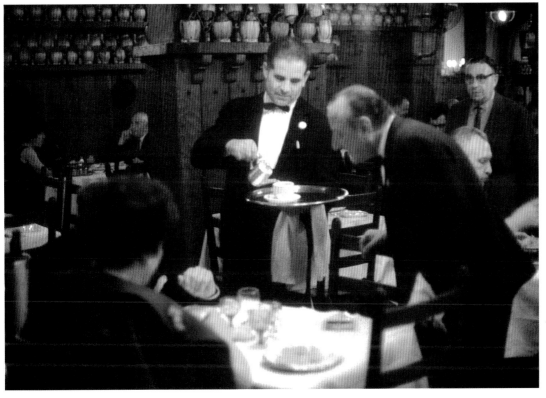

❹

WHERE TO FIND GREAT PICTURES: SOME U.S. CITIES AND STATES

❶ Church near Bennington, Vermont. This beautiful state ranks forty-ninth in population. Look for white steeples everywhere and gorgeous colors in fall. My 500mm fixed-aperture f/8 mirror telephoto lens was on a tripod-mounted F-2 camera. Exposure with 100 ISO film was 1/125 at f/8.

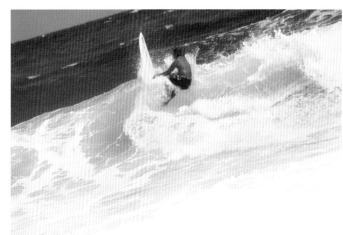

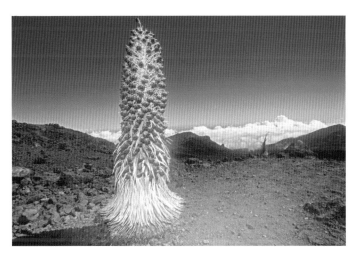

❷ – ❻ Hawaii. Reaching beyond the crowded areas, I drove around the state's four biggest islands. The pineapple stand was on the north shore of Oahu; the undeveloped beach was on the eastern side of Kauai; the palm bird hung from a tree branch at Lahaina Harbor, Maui; and the endangered Hawaiian Silversword plant bloomed at over 10,000 feet on top of Mount Halakealea National Park, also in Maui. All were shot on 100 ISO film, and exposure was read from in-camera and set manually. The dusk and beach shots were made with a 50mm f/1.8 lens; for the pineapples and plant, a 20mm lens was used. I added TTL flash fill to the Silversword shot that was semi-backlit—note the position of the plant's shadow.

WHERE TO FIND GREAT PICTURES: SOME U.S. CITIES AND STATES *(continued)*

7 Harrah's, Laughlin, Nevada. It's hard to photograph gambling, or "gaming," as the casinos like to call it, but Harrah's willingly gave me permission to photograph inside, provided I got advance permission from their clients. Here my tripod-mounted F-100 was used with a 28mm f/2.8 lens wide open, plus TTL fill flash. Shutter speed was 1/5. The blur of the ghost image adds interest to the shot, I think.

8 Downtown casinos, Las Vegas, 1600 ISO film, 1/60 at f/4; camera was on tripod. My TTL flash was on-camera and set at minus 2/3 of a stop for subtle fill light.

9 New York City. My adopted city is great to photograph all year round, in all five boroughs. Spring and fall especially have extraordinarily clear light. Have fun focusing on the symbol of America and other world-class local sights. This shot of a tourist at Lady Liberty was made in April with 400 ISO Tri-X film rated at 200; a deep yellow filter darkened the sky. Exposure was 1/250 at f/11.

10 & **11** Two digital images made during New Year celebrations in New York's Chinatown. Fuji S-1 digital camera rated at 320 ISO, 50mm f/1.8 lens, 1/60 at f/5.6; overcast light.

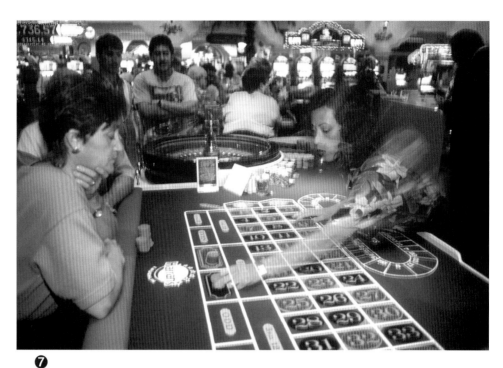

7

8

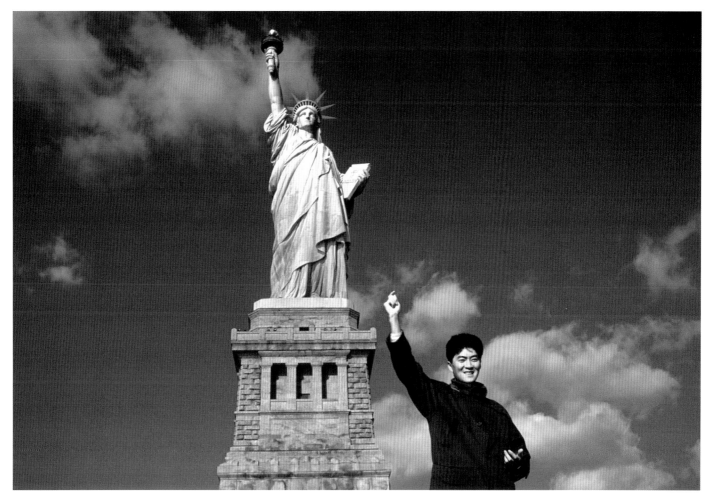

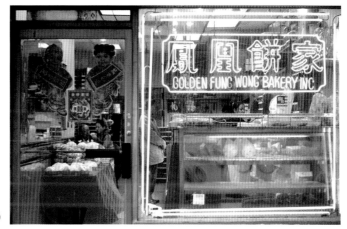

the latest official travel advisories (warnings), find bargain travel times and rates, and get lists of upcoming happenings for United States and worldwide destinations.

Researching, Planning, and Booking Travel

There are four great resources available for planning any trip: friends and acquaintances with tastes similar to yours who have visited the place you are interested in fairly recently are invaluable. A good Internet search engine is amazing when you know how to ask it questions that will sort the wheat from the chaff. (I rely on Google.) Illustrated guidebooks will give you both a background on a place and some idea of what it looks like, and will help you shortlist the things you most want to see and do. I like *Insight* and *Lonely Planet* guides especially. A good travel agent can be helpful, though most today can't spend hours planning a moderate-budget itinerary. Use them for making car-rental, airline, and hotel bookings—or do those chores on the computer or telephone yourself.

First, commit to where you want to go. Then, decide when you want to go, or can go. Firm up airline reservations; hotels and cars, if needed, can be booked later. Arrangement for local tickets and the like are often best made on arrival.

Talk to your friends and decide if you want to spend as long as they did in one place, or if you prefer to tour a region or country. Perhaps an organized tour will be cheaper, safer, or cover more ground than you could traveling independently. Make a checklist of what's truly important to you, and what's optional. Outline your principal photographic objectives too (see page 114).

If booking your own travel arrangements, be sure to read all the fine print, check and re-check all prices and routings and conditions before committing yourself to paying what may be nonrefundable charges. Print out two copies of everything: flight connections, tickets, itineraries, and reservations immediately. Keep one copy of these precious documents in a safe place. Carry the other when traveling. Bargain rates especially may be nonrefundable, or can be changed only on payment of a stiff penalty. If available, get regular tickets, not electronic tickets, when traveling overseas. Arrange for travel and medical insurance (see box); trip-cancellation insurance may also be a worthwhile investment if you are taking an expensive safari, tour, cruise, or even a photo course package.

Medical and Other Travel Insurance

When in Mexico in May 2003, I stayed in a small clean hotel in Oaxaca. The only electrical outlet was for the TV, near the ceiling. I plugged in my laptop, burned my digital images to disc and went to sleep. In the morning my guide/driver banged on the door early, as requested. I could not unplug the computer, I tugged and tugged but nothing happened. So I stood on a chair and gave the plug a good yank. The whole electric socket assembly came out of the wall, and my hand flew back into a high-speed steel electric ceiling fan running at high speed. My assistant for the trip, John O'Leary, rushed me to a local clinic, where a competent doctor cleaned the deep wound, gave me an anti-tetanus shot, stitched and bandaged me up, and prescribed antibiotics and strong painkillers. I paid the modest price for treatment and drugs in cash, but got receipts for my insurance company, which later partially reimbursed me. I was able to finish the trip, and another

back-to-back one to Jamaica. However, my thumb was still immobile at the end of that trip, and I ended up at a hand specialist back in the States. I had to have surgery to repair a severed tendon.

Check to make sure that your insurance policies cover you overseas. Many tour operators suggest you buy a package that covers the cost of your trip plus medical expenses. Medivac insurance will pay for an ambulance flight home if needed. Trip-cancellation insurance is available too. Rented-car insurance may or may not be covered under your auto policy—be sure to check in advance of renting a car anywhere.

Finding Bargain Rates and Their Pros and Cons

The bargain Web sites I use are Priceline.com, Expedia.com, and Orbitz.com. I have had good experiences with all of them. In the last two years, I have flown to Maui, Hawaii, for $500 roundtrip from New York (a successful bid made in September 2002 on Priceline); when there, I scored $75 inter-island tickets to visit Honolulu and Oahu, Kauai and the Big Island. National car rental rates were bargains while in low-season Hawaii, and big hotel discounts were available at airports within the Aloha State—my beautiful room, a seven-minute walk from Waikiki beach, cost $50 per night. In March 2003, I took my daughter to Paris for $650 round trip for both of us, including taxes (that was a two-person special offered by Air France). We stayed for two weeks with family and friends. I flew to Mexico City from New York in May 2003 for $300 plus tax (via Priceline again), and I went to London from New York for $320 roundtrip in March through April on Virgin Atlantic Airways.

Living in a transportation hub does offer a wide range of options, of course, but bargains exist almost everywhere if you are prepared to travel at fairly short notice. I've also flown to French Polynesia, Arizona, Los Angeles, and New Orleans spending no cash at all, using frequent flyer miles.

The only downside I can see to cut-rate or "free" travel is that holiday periods are never available, and there is usually a stiff penalty if you have to change a reservation or miss a flight connection. (Be sure to allow at least two hours leeway if scheduling flights with one or more stops. The longer the flight, the longer the connection delays that can be expected.)

If you publish travel features on a regular basis, know that bargain fares, hotel discounts, or even free trips may be available to you. You will have to supply excellent credentials and show plenty of evidence of published work.

The Telephone

Many travel enquiries are best made on the telephone, especially if you must make last-minute changes to plans. Hotel phone charges can be very high; you may save a bundle by carrying a cell phone or buying a local telephone card. My Sprint cell works over most of the lower forty-eight U.S. states, and from most locations in Alaska and Hawaii too. I paid no extra charges to call New York every night from Hawaii for three September weeks two years ago, because I stayed within my allocation of minutes.

Buy phone cards from tobacco and newspaper shops throughout Europe; most phones there don't

WHERE TO GO TO FIND GREAT PICTURES: MEXICO

All shots were made digitally at 100 or 400 ISO settings. I aimed the S-2's in-camera meter at a mid-toned area of the composition, moving in close to get correct exposure for faces, and setting shutter speed and aperture manually. I do, however, now love autofocus!

❶ Mexico. Our southern neighbor has amazing churches, ancient cities, wonderful crafts, and much else to photograph. Try to get away from the border towns! This shot is a view over Taxco and was made with my S-2 camera, a 400 ISO setting, and a 70–300mm lens at full extension, making it the equivalent of a 420mm lens on a film camera. Exposure not recorded.

❷ Blanket seller, Xochimilco, Mexico.

❸ Painted folk carvings, Mitla market, Mexico.

❹ Mariachi singer, Garibaldi Square, Mexico City, Mexico. (I had to pay him a few pesos for this picture.)

❺ Mexican church interiors are extraordinarily moving for this non-religious person. This Christ figure of polychromed wood adorns the altar of the cathedral in Taxco. Fuji S-2 digital camera rated at 1600 ISO, 14mm f/2.8 lens; exposure 1/30 at f/2.8. The camera was handheld because tripods were not permitted. I made several shots to insure that I had some images without blur caused by camera shake.

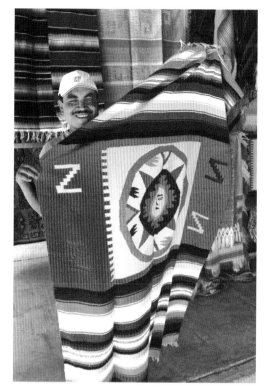

❷

❸

❺

❹

WHERE TO GO TO FIND GREAT PICTURES: EUROPE

❶ Alnwick Castle, Northumbria, U.K. Rural England is still unspoiled, beautiful, and, for all but six peak weeks during school summer holidays, crowd free. This May shot was made with 20mm lens, 50 ISO film, and at 1/125 at f/8-11.

❷ Bohemia, Czech Republic. Quaint villages, ponds surrounded by fat geese, and friendly country folk are all to be found here. I caught this harvest scene one September with an 80-200mm lens, 64 ISO film, and an exposure of 1/250 at f/5.6.

❸ Santorini, Greece. All the islands in the Cyclades chain are gorgeous, and crowded in high summer. This simple shot is a favorite souvenir of mine. I took it years ago, and don't remember the lens or settings used.

❹ Man and two children in a boat, Stavangerfjord, the Norwegian fjords. (Go in May or June if possible.)

❺ A fjord-side village near Bergen, Norway. Both 64 ISO film, 80-200mm f/2.8 lens, handheld. Exposures were not recorded.

❶

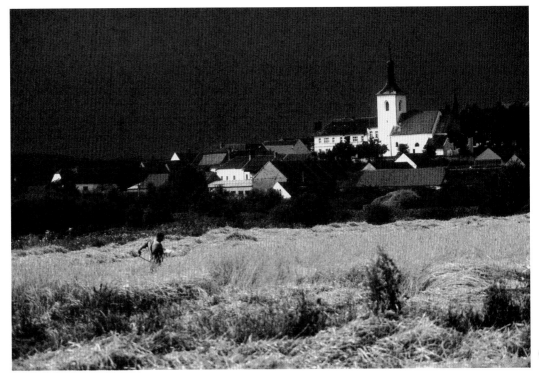

❷

❸

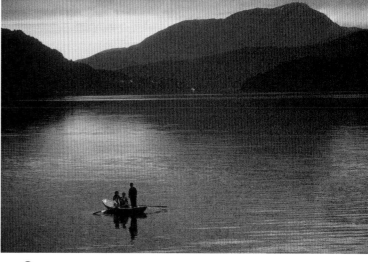

❹

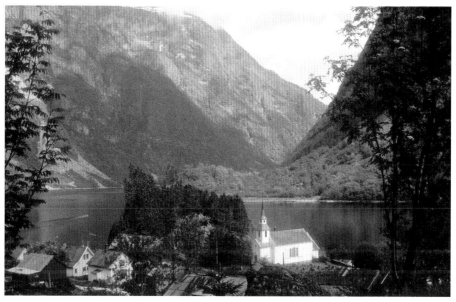

❺

WHERE TO GO TO FIND GREAT PICTURES: EUROPE *(continued)*

❻ & ❼ Holland. If you drive off the main highways of this extremely modern country, there are still many picturesque corners. The costumed lady and traditionally painted buildings are to be found in Volendam, and the tulip displays are stupendous at Lisse, near Haarlem, in March and April every year.

❻

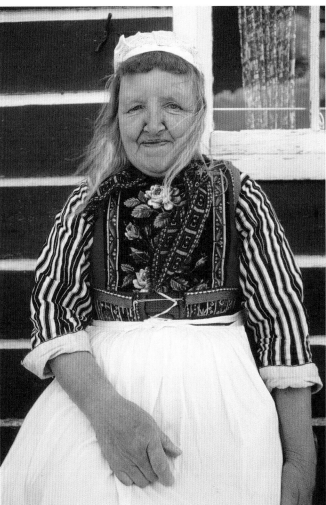

❼

accept coins. Cell phones can be rented throughout Europe too, and are a great convenience. You can rent phones in many second and even third world countries too. Contact the commercial department of a country's consulate, or call the embassy in capital cities, to learn if cell rentals are available.

If you are going to a truly remote place and need to keep in touch with home or business or patients, you can rent a satellite phone in the United States and take it with you. A psychiatrist friend of mine and her businessman husband did this a year ago when they went on an African safari. The satellite rental was $49.95 a month, plus about $4 per minute for calls. She told me the phone was quick to set up and use, and reception was excellent. You can find satellite phone rentals on the Internet.

Current Security Issues

It's popular to say at present that "we are living in a dangerous age." I think that an age is always dangerous somewhere. If one is a true traveler one must learn to cope with that fact. I refuse to let terrorist acts and threats prevent me from going where I want, but I'm no photojournalist and am not going to take silly risks. Maybe I'm fatalistic because I lived in England as a small child during World War II, and can still remember watching massed planes flying low over my house on their way to support the invasion of Normandy. Or perhaps it's because when I first came to America in the 1950s the Cold War was at its height. I worked in a New York office, and we were often asked to hide under our desks during air-raid drills, not that they would have been much protection if an atom bomb had been dropped. Similarly, New York had a big crime wave in the 1970s, and we all learned to keep doors and windows locked and to avoid tough neighborhoods and subways late at night, or flashing cash or jewelry or valuable camera equipment at anytime. Those are all still good tips for travelers everywhere, including most American cities and even remote rural areas because in those places a lot of people carry guns. Europe has its dangerous places as do all other parts of the world. Yet people in most countries go about their daily lives peacefully and pleasantly; very few have been crime or terrorist victims, and tourists, if alert, will not suffer evil consequences.

Safety Perceptions and Realities

Be aware that all official government travel advisories are designed to emphasize problems and list all dangers. Some travel warnings have political undertones too, and some, to me, are quite funny. U.S. travelers to the United Kingdom are currently being warned about the possibilities of contracting mad cow disease, for instance. That's a multimillion-to-one chance. Yet, no one, anywhere, is ever warned about routine highway dangers. But 48,000 people were killed in accidents on U.S. highways in 2002, according to a report I heard on TV only yesterday.

Here is my current take on travel security:

I am not going to countries that are predominantly Moslem at the moment, nor do I plan to spend time in any place where there are high numbers of SARS or bird flu victims, or, of course, local insurgencies. Apart from considerations about health and safety, I won't be able to sell my type of pictures or stories about such places anyway.

I am old enough to remember that risks and dangers and problem countries change. Eastern Europe was closed to most travelers in the 1950s and 1960s. So were Russia, China, and Vietnam; but

WHERE TO GO TO FIND GREAT PICTURES: ASIA AND THE PACIFIC

Asia is interesting, although many of its cities are now extremely modern-looking. However, traditional costumes, beautiful landscapes, and nice people are easily found there, especially outside the biggest towns. Australia is great fun and scenic too, while South Pacific beaches are almost everyone's fantasy.

❶ Ayer's Rock, Yulara, Australia, at sunrise. Early and late is when it flames red.

❷ – ❹ Thailand. Temple decoration, masked dancer, and floating market; all are to be found in or close to Bangkok.

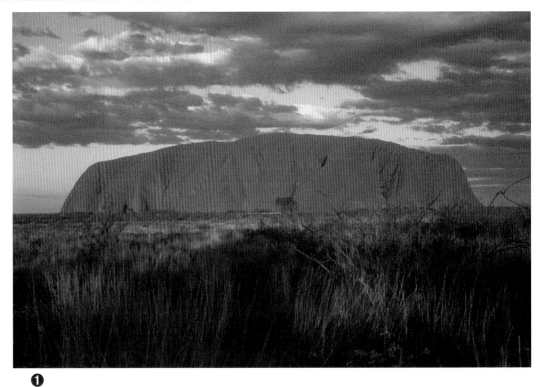

❶

❷

❸

❹

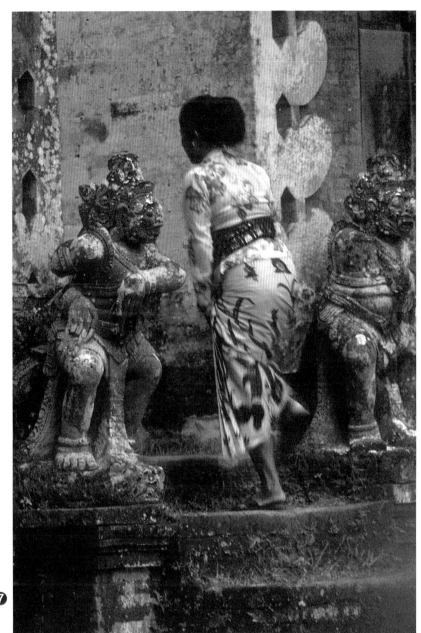

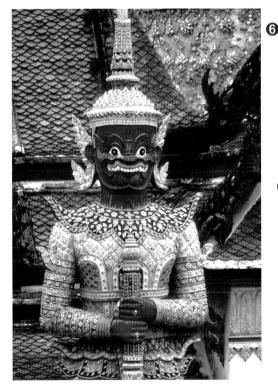

❺ Taipei, Taiwan. Student at the traditional Chinese Opera Academy. This image has been widely reproduced.

❻ Guardian figure, Royal Temple, Bangkok, Thailand. F-2 camera, 80–200mm lens, 64 ISO film. Exposure was 1/250 at f/4.

❼ Woman entering temple, Bali, Indonesia. On a cloudy day, I used 64 ISO film and an 80–200mm lens. Exposure was 1/60 at f/5.6

hundreds of thousands of foreigners now tour China annually, many visit Russia, though the war in Chechnya has affected the tourist industry, and Vietnam and Cambodia are now being visited by the American avant-garde.

My British-schoolteacher niece and her partner, great travelers both, spent their long summer holiday in 2002 touring Vietnam, which is experiencing a tourist boom. Apparently it has beautiful beaches and a pleasant Asian/French ambience and great food, mixed with, not surprisingly, a touch of American "can do" energy.

Many U.S. citizens now visit Cuba via Mexico, Canada, or Jamaica, though officially it's still proscribed for us—for political, not security reasons. Europeans have enjoyed vacations on the island for years and for them it's a hot travel destination.

There are plenty of wonderful places to visit. Australia, Canada, Mexico, and most of Latin America are currently favorite tourist destinations. Or, explore the wonderful variety of the United States if you feel nervous about overseas trips at present.

Find up-to-date security and travel information on official Government and other Web sites. Some of the most important are listed in the Resources section at the end of the book.

Packing

Here is a summary of how I pack in order to travel as efficiently as possible. I carry all my photo and digital gear including film and media cards, plus my laptop computer, in a wheeled bag that fits under an airline seat, or I use a big, well-padded purpose-made photo backpack/computer bag. The magic size for carry-on luggage seems to be 9" × 14" × 22" at present (but do check that with your airline). I put all documents in this, and carry copies in my document wallet that loops around my wrist.

I carry all batteries—suspect in some countries and liable to be confiscated from your carry-on bag—chargers, extension cords, and a moderate size Gitzo tripod in my checked luggage. For this, I use an inexpensive air-crew-type black wheeled bag, that also carries my clothes and toiletries. If I have little room for such items, that's OK with me. It's fun to buy clothes overseas, and local clothing makes you less conspicuous.

Packing Film for Airline Travel

These days, when I travel by plane, I shoot digitally. Digital media is not affected by hand-luggage screeners; however, do not carry the media cards in checked luggage and do not keep them in your pocket when walking through magnetic screeners.

Slow or moderate-speed films are safe if put through carry-on luggage scanners once or twice, but if you are going through several airports, the multiple scans might in fact cause slight degradation of your film. That's more than I'm willing to risk. So, if shooting film, I take cassettes or rolls out of their boxes and carry them in strong, clear plastic bags. I arrive at the airport early and ask for a hand inspection of my film. In the United States, federal law currently permits this, though individual interpretations of this ruling may vary. So, I carry a few Sima lead bags (buy them at good photo stores) and put film in it if hand inspection becomes a big hassle. In most foreign countries, officials insist on putting film through the hand luggage screener. Again, I use Sima lead bags and I have not

yet had any film damaged. I do repeat though, that you must never, ever put any film or any digital media or unwritten CD-ROMs or DVDs into your checked luggage. The powerful scanners used on checked baggage can and probably will cause damage to your images.

Warning, Warning, Warning

Warning: Never, ever put film or digital media of any kind into any checked luggage when traveling. Apart from the real risk of theft, the airport scanners used on checked luggage are much stronger than those used to screen carry-ons. Both Kodak and Fuji advise that they will affect film of any speed and almost certainly will damage pictures. These scanners will also adversely affect digital media cards and CD-ROM discs. *Always* carry valuable equipment, *and* film, *and* media cards and discs of all types with you, and keep them close at all times.

Obviously, I am always patient and polite with all security personnel. Thus far, in many multiple airport trips to Europe, the Caribbean, Asia, the Pacific, Australia, and South America I have not suffered film damage, but I pray a lot and sweat a lot.

When traveling by car, I pack carefully and never, ever leave equipment unattended anywhere for any length of time.

New Regulations

The following are the current regulations from the U.S. Transportation Security Administration regarding transporting film and photographic equipment:

For photographic equipment, you may carry one bag of photographic equipment in addition to one carry-on bag and one personal item through the screening checkpoint. The additional bag must conform to your air carrier's carry-on restrictions for size and weight.

For film, the equipment to screen checked baggage will damage undeveloped film. Pack your undeveloped film in your carry-on bag. High speed and specialty film should be inspected at the security checkpoint. To facilitate hand inspection, remove your undeveloped film from the canister and pack in a clear plastic bag.

For more information, go to *www.tsa.gov/public/interapp/editorial/editorial_1248.xml.*

Last-Minute Things to Do before You Leave

- Twenty-four hours before a flight, reserve or order transport to the airport if needed.
- Pack, carefully. Put tickets, passports, and credit cards, and prescriptions if needed, in a secure place. Leave copies of all these in another bag, and at home too. Sometimes I carry a wrist wallet, sometimes a money belt.
- Make a list of what you must pack, and check things off as you do it.
- If no one will be at your home, give someone a spare set of keys and get their phone numbers

so you can check in occasionally. Leave your own contact numbers too. I do not leave an "I'm away" message on my answering machine, but do say I'll call you back in a day or so.

- Stop mail and paper deliveries; turn off refrigerator and water heater and arrange to have some-one water your plants and/or feed/exercise/pet your animals.
- Get some clean one-, five-, and ten-dollar bills. These are acceptable in many foreign countries.
- Make a shooting list.

The Shooting List

This should list "Must Haves," "Important Objectives," "Optional Subjects," and more, as you wish.

My must-have list always includes icons of the country, hotel/resort facilities and food, people somehow characteristic of the place I'm going to; art, craft, or even produce markets; and outstanding mountains, rivers, lakes, beaches, or other scenic attractions. Also, historic buildings or subjects that illustrate what makes a place unique and why you should go there.

Allocating Time

If you are on vacation, of course, how you spend time is entirely up to you. But to get great pictures I strongly suggest that you allocate at least a couple of uninterrupted hours in early morning and late afternoon to concentrate on photography, preferably alone. To this end, your spouse, lover, kids, friends, or any combination of the above should be actively encouraged to pursue their own interests, be they museum-going, scouting for bargains in shops and markets, people watching in cafés, writing postcards home, or whatever. My daughter loves all of the above.

Serious still photography is essentially *not* a group occupation—one is much more sensitive to atmosphere when undistracted, and I usually prefer to shoot alone.

If your nearest and dearest loves getting up early and enjoys wandering or driving through strange neighborhoods, is always willing to go around that next corner or explore a village a few miles down the road, is good at communicating with people but knows when not to talk, has a sense of humor, can wait patiently whenever you stop to shoot a person or scene—then you have a paragon of a traveling companion. Value him or her highly. You might encourage a wonderful travel compan-ion to shoot videos while you shoot still images, or try shooting in black-and-white while you capture images in color. Just train any and all photo companions to never, ever stand so they intrude into your picture "frame," or to shoot from right over your shoulder, or to distract people when you are photo-graphing them. That way, you can avoid any big family dramas while on the road.

For professionals, and those with professional ambitions, know that a professional photo assis-tant is unobtrusive, can anticipate one's needs, doesn't talk all the time but can chat when that's relax-ing, and never complains about the food, the accommodations, or driving for long hours. Most espe-cially, he never, ever lets on to clients or models or others you're working with that he thinks he's a better photographer than you are. Again, such assistants are rare beasts; treasure them.

FOOD

Photograph food before anyone touches it; it must be pristine or it looks disgusting in pictures! The table must be immaculate too. Here, wide-angle lenses enabled me to include food and the colorful backgrounds.

❶ Supper at an outdoor taverna, Santorini, Greece. The salad with feta cheese and a local wine was delicious! At sunset with 64 ISO film and a 20mm lens, I shot at 1/60 at f/4.

❷ A Caffé Granita at the Café Florian, St. Mark's Square, Venice, Italy. I metered off the shaded table and used a 28mm lens and 64 ISO film. Exposure was 1/60 at f/4; I knew that the sunlit portion of the background would be slightly overexposed, so composed to compensate.

❶

❷

BEACHES

Gorgeous empty or near-empty beaches appeal to almost everyone. I like to shoot beaches at around 8:00–9:00 AM or at around 4:00 in the afternoon, as the tide is falling. That way, I get light that looks like bright sunshine, but avoid evidence of crowds, footprints, rubbish, etc.

❶ – ❸ These pristine beachscapes were made in Negril, Jamaica, with my Fuji S-2 digital camera at its 100 ISO setting (the minimum on most digital cameras). I shot with an inexpensive 35–70mm f/4–5.6 zoom lens. In this light, with 100 ISO film or digital media, you'll get good beach exposures every time at 1/250 and f/16. These pictures work as fine art and can have commercial appeal too.

❶

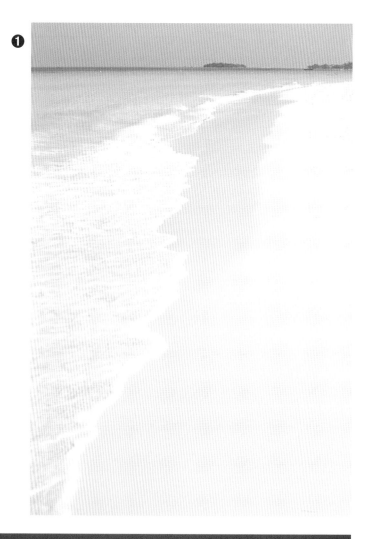

❷

❸

❹ & **❺** Emphasizing the crowding on popular beaches can make for strong images, especially if you compress the scene with a telephoto lens. It's often useful to shoot both horizontals and verticals if you are shooting a picture story. In Dalien, China, my 80–200mm zoom captured university students and kids with a flag. On 64 ISO film, exposure was 1/250 at f/11.

❻ North Shore, Ile d'Ouessant, Brittany, France. A very different beach on this winter-storm-wracked island off of France, part of the Armorique National Biosphere reserve. Some of the boulders are as big as human heads, and none may be removed. I lay on my stomach, tilted the lens slightly forward, and focused one-third of the way into the composition to maximize depth of field. FM-2 camera, 20mm lens, and 100 ISO film in weak sunlight, base exposure was 1/125 at f/11, plus brackets.

Keeping Notes

Collect and keep locally printed guidebooks, maps, brochures, bus tickets, postcards, museum plans, and any other informative material you can find, to help you caption pictures later. When my collections of papers get bulky, I stuff them into an envelope and mail it home. I do the same thing with receipts, large and small. Some people tape notes, or write descriptions on a laptop each night. I'm a bit lazy about that, but do keep a record of lenses and exposures used, for my "how to" photography books. In a year or two, you'll probably be glad you did all or any of the above.

Keeping Track of Expenses

Whether you keep track of what you spend on a trip to keep the family budget intact, or to compile an exact record so you can be reimbursed by paying travel clients, do this faithfully. Do this too for Uncle Sam or other tax men if you shoot professionally now, or hope to sell pictures later. Such expenses are tax deductible even if you aren't selling pictures yet. But, you must keep notes not only of money spent, but also of all the marketing calls you make, letters you send out, stock pictures submitted, and more. Years ago, a CPA urged me to keep a "day book" of my activities and to pay as many bills as possible with a credit card. (I use the American Express card because it has no pre-set spending limit.) I save all receipts, tickets, restaurant checks, and more, even if only for tiny amounts, and staple all receipts to big sheets of paper, different color sheets for different trips and different currencies. These are filed by year, and I keep all financial records for seven years, as required by the U.S. Internal Revenue Service. Clients may need to keep your original receipts; then save copies for your records. I have done all these things faithfully and have survived several tax audits unscathed.

I now write checks and keep my checking account more or less balanced, with the aid of Intuit's Quicken program for the Mac.

Copyright and Model Releases

Model releases are needed to commercially publish pictures of anyone, or any animal or object or building that is private property. (An exception is a building shown small in a cityscape, etc. For model releases that you may copy, use, and adapt, see below.)

U.S. federal law, and most other countries' copyright laws state that copyright (ownership) always belongs to the originator of a creative work, *unless the originator sells or assigns the copyright to someone else*. Protect your copyright by marking all images with a copyright stamp.

It should read:

> Photograph © Copyright <Photographer's name> <Year, e.g., 200_>
> (Choose the year of creation or the year of first publication.)
> All rights reserved.

Photographers starting a professional career should be aware that some clients will ask you, or require you, to sign a "work-for-hire" agreement assigning them the copyright as a condition for getting the job. Avoid this if you possibly can, or you will not be able to accumulate files that may be of great value years later.

Staff photographers must usually assign their copyright to employers, like newspaper publishers, but may be able to negotiate residual payments from reprint sales, or for purposes of fine art or exhibition. Personally, I've sold copyright outright only on a couple of occasions, for quite a lot of money.

The U.S. Copyright Office Web site is at *www.copyright.gov*. Contact them to learn how to register your copyright.

The essential books to read on both copyright and model-release issues are Tad Crawford's *Legal Guide for the Visual Artist* and the *ASMP Guide to Business Practices in Photography*, 6th Edition.

Sample Model Release Form

This model release may be copied or adapted for your own use. Add your name and address if you wish. It will reassure the models, and I have never had any problems from doing this.

MODEL RELEASE

Date: _____

Place: _____

I, _____
<div align="center">*(Please print name clearly)*</div>

hereby grant _____

permission to use, copyright, and publish the photographs taken of me today for purposes of advertising and trade in all lawful media.

Signed: _____

PART VII
Showing Work

Twilight is my favorite time to shoot cities and towns. This view of the floodlit castles and spires of Salzburg, Austria, was made from the terrace of the local casino with a tripod-mounted FM-2 camera and 80–200mm f/2.8 zoom lens. I metered off the mid-toned sky and zoomed in until the composition pleased me. Exposure with Fuji Velvia 50 ISO film was 1/4 or 1/2 at f/11. The pinkish tone is characteristic of longer exposures with this film.

How to Edit Your Work

Whether you make digital images, or shoot slide films, or negative film for prints, a critical part of serious photography is editing your work.

First, burn original digital images to CD-ROM discs or have a pro-lab or mini-lab do it. You can have the lab make inexpensive 4" × 6" digital mini prints or you can make them yourself. (Recommended photo software programs and digital printers are listed in the Resources section.)

Edit slides on a light box and have mini-prints made from negative films.

If you carefully choose only your best shots to send out as e-mail, post to a Web site or to make prints and enlargements for a quality album or a portfolio, you should soon gain a reputation as a good photographer. If you shoot regularly you will quickly accumulate pictures. When you have a fair number, give yourself a retrospective, decide where your strengths and interests lie, and follow them up. I still do this periodically to keep fresh.

Store all work carefully. Use good quality CD and DVD discs. Mark contents with an alcohol-free pen made by Maxwell and others—never use ballpoint pens—and keep discs in protective "jewel boxes." Slides, negatives, and prints ideally should be stored in a cool place, in archival plastic sleeves, or non-acid dust-proof boxes. These items are available at good photo stores or from Light Impressions (see Resources). I store my valuable film and digital originals in a big fireproof safe; others are hung in metal file cabinets that I bought used and cheap.

Adjusting and Retouching Digital Images

Most digital pictures can be improved by downloading to a computer and then adjusting the color, sharpness, and more with one of today's "digital darkroom" programs. With them you can crop, retouch minor flaws, modify color and contrast, and otherwise manipulate digital originals before making enlargements. To retouch originals shot on film, the images must first be scanned and burned to disc, by you or by a digital service bureau. And an increasing number of consumer photo labs as well as professional service bureaus now offer inexpensive scanning service as well as digital prints and enlargements.

For retouching and adjusting my images, I rely on the industry standard, the professional software program Adobe Photoshop. A cheaper, simpler, also excellent version is Adobe's Photoshop Elements. Both come in Mac and PC versions. New Macs now come with the Preview and iPhoto programs included, which provide a good way to view and adjust images. My photographer friend Pat Fisher, who uses PC computers, highly recommends the inexpensive ACDSee program for quick viewing and making some photo adjustments. It's newly available for Mac OSX.

Personal/Self-expression Travel Pictures

To get the most pleasure out of your travel pictures, share them with others. To this end, plan in advance to make an album of travel prints, or a digital or film travel slide show. You can enlarge and frame your best shots as an exhibit for your home or workplace, or e-mail individual pictures to

TO CROP OR NOT TO CROP

The photographic ideal is to compose and crop unwanted elements "in camera" and to print the whole image "full frame" unless a layout or page size dictates otherwise. But sometimes you can't or don't frame accurately. Then it's okay to crop, in the enlarger if printing traditionally, or via a digital retouching program. Of course, if you have to crop out too much your image will lose quality. The crop shown here is acceptable, I think.

❶ I liked the glass portion of the pub window shot, and scanned the image to disc. Then I cropped out the distracting white frame and also tweaked, or upped the contrast, with Adobe Photoshop.

❶

❷

❷ Pub Window, Richmond, U.K. A quick grab shot. On a cold December day, I did not waste much time before going to the pub! F-100 camera, 28mm lens, 100 ISO film, 1/60 at f/4 in London's low winter light.

❸ Tiger at the National Zoo, Washington D.C. I photographed him with a 70–300mm lens on a Fuji S-1 camera, and later cropped to eliminate a concrete wall in the background.

SIGNS

Pictures of signs can make headings and spacers for albums, help you remember locations and write captions, and even be graphic or amusing images in their own right. Here are a few I like:

❶ There aren't many funky spots remaining in Maui, Hawaii. I took this fruit-stand sign in 2003 and wonder how long it will be before this land is developed. F-100 camera, 20mm lens, 400 ISO film rated at 200. Exposure was 1/500 at f/11.

❷ This French sign marked short distances in the long-ago days when most people walked everywhere. S-2 digital camera rated at 100 ISO, 50mm lens. Exposure was 1/250 at f/11.

❸ An old road sign in a Cotswold Village, U.K. 80mm lens, 400 ISO film. Exposure was 1/125 at f/4 on an overcast day.

❹ No need to translate this sign in France, where dogs rule! S-2 digital camera rated at 100 ISO, 50mm lens, Program mode.

❺ A relaxed cow browses near a Burger King in Negril, Jamaica. S-2 digital camera rated at 100 ISO.

❻ Millions of pictures of old churches like this one in Normandy, France, are taken by tourists every year; many are dull. I included the modern sign to give a familiar scene a fresh twist. My 14mm f/2.8 lens on a Fuji S-1 digital camera rated at 320 ISO was focused 1/3 into the scene for maximum depth of field. Exposure was 1/500 at f/16, handheld; I leveled the camera extremely carefully to avoid distorting the image.

❶

❷

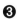

family and friends as attachments. To show work to the widest audience, plan to create or have an expert create a Web site.

The best holiday album I ever saw was made by an English acquaintance, Rosemary Faith. She went with her husband and three small children to stay in a budget-priced caravan park on the Dorset cliffs in England's mild southwest, a popular tourist area. She had a camera and two lenses—I have no idea what they were. She made medium, wide-angle, and close-up shots, of her family squashed into the caravan, of the crowded caravan site, and the marvelous view it had of cliffs and the deep green sea below. She made shots of picturesque locals in the nearby fishing village and their boats, of local shopkeepers and funny signs and close-ups of racks of the raunchy seaside postcards beloved by the English. She snapped the kids building elaborate sandcastles that were soon washed away by surf, and of her tired husband who seemed to spend most of his time snoozing in a deckchair while pretending to read the *Times*. She didn't forget to show her family gorging on big plates of fish and chips and wildly decorated ice-cream cones, and went to a local pub one evening with her husband, who drank foaming mugs of beer.

Rosemary's album finished with a posed group shot of everyone, including herself, looking happy, tanned, and relaxed standing in pouring rain at the local station waiting for the train back to London. Each was holding a bright plastic beach toy. A passerby apparently snapped the shutter.

I saw Rosemary's album at her cousin's—my oldest friend's—house, and was enchanted even though I barely know the people in it. Obviously, this untrained photographer has natural talent, but she had also taken great care to vary her subject matter, and to edit ruthlessly. There were no out-of-focus or badly exposed prints in the collection, no boring near-duplicates and no shots that were so obscure that their point had to be explained to the viewer. Sadly, I don't have access to those pictures now, but I've included some snaps that I made in Jamaica to give you an idea of where to start.

To successfully exhibit enlargements, whether for private wall display in small groupings or planned as a larger gallery exhibit with the aim of selling prints, in my opinion you should choose pictures that have a unified theme. Too many mid-level photographers' photos shows jump distractingly from one type of subject to the next. I also think that it's most effective to identically mat and frame pictures for exhibits.

Slide Shows

To make a slide show, group your images so that each visually leads to the next. My best suggestion for how to do this well is to study television commercials and see how, for instance, a red apple blends into a red sunrise, then the sun turns orange and the screen shows a close-up of an orange grove, then cuts to juices pouring from containers. You get the idea. Many of these short sequences are visual masterpieces and are made by great directors. I enjoy commercials best with the TV's sound turned off.

With scanned digitized prints or slides, or with original digital images, you can edit and sequence pictures on your computer screen. Moderate-price Epson and HP scanners include software for doing this, and the sequenced images can also be shown on your TV screen. Other computer programs offer similar possibilities. You can also copy the edited, sequenced images back to a compact flash card or

a Microdrive and show them on a TV screen hooked to your digital camera. Make a permanent digital slide show with a DVD burner and appropriate software.

Digital slide shows can be sequenced on many photo manipulation programs (see Resources section) and then burned to DVD for viewing on your TV set. Roxio's Titanium Toast software is excellent for this. Not all DVD players will work with home-made picture discs, but some models will—check with electronics dealers for the latest on compatible DVD players before you invest. Epson makes excellent digital projectors that will throw images long distances. These are expensive and popular with professional photographers and corporations.

With slides, sequence the pictures on a light box, then arrange them in the slots of a Kodak Carousel projector wheel. These wheels come with 80- or 120-slide capacity, and fit the almost universally used Kodak Ektagraphic slide projectors, the only kind to buy in my opinion. Never project valuable original slides; they will fade, buckle, and get dusty quickly. Have "dupes" (duplicate slides) made.

Web Sites

Web sites are a great source of travel information. They are also a new and amazing way to display your work to a worldwide audience and to view other photographers' work too. They are not difficult to set up if you have good to excellent computer skills, but it may cost you quite a lot of money if you must pay an expert to design, program, and set up a sophisticated site on the Internet. The site must be updated on a regular basis too. To get some ideas, type "travel photographers," "travel photography," and "travel magazines" into Web search engines like the one I prefer, *www.google.com.* You will find hundreds, even thousands of listings. When you have some spare time, browse through a few of them to get ideas and maybe inspiration, but never rip anyone off, of course. My Web URL is *www.susanmccartneyphoto.com.*

WHERE TO GO TO FIND GREAT PICTURES: BEACHES ANYWHERE

All of these photographs were made in Jamaica in the West Indies, and anyone with a point-and-shoot or film or digital camera with a interchangeable or zoom lens can make this type of picture. Just be sure to avoid shooting under overhead noon sun and frame your shots carefully to exclude unnecessary elements in the composition.

TRAVEL-PICTURE STORIES

Picture stories are most often about people or events, but don't have to be. For fun, I started snapping these VWs on a recent trip and call the series "The Beetle is alive and well and living in Mexico."

These photos were shot in Taxco, Oaxaca, and Mexico City, Mexico, with my S-2 camera and 20 and 28mm lenses. ISO rating was 100, and exposure 1/250 at f/11, f/8, or f/5.6, depending on whether the prevailing light was sun or open shade.

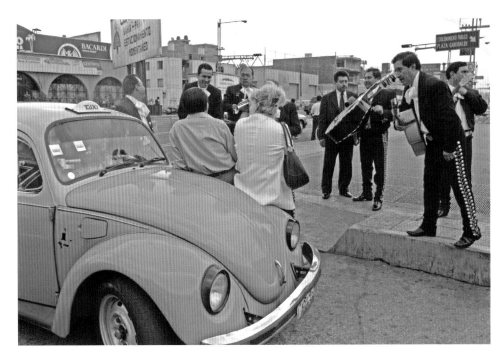

PART VIII
Going Pro

On assignment in the far west of Ireland several years ago, I spotted this boy who was cutting peat. After talking to him I took several pictures. Here the dog placed itself perfectly in the composition, making it one of my favorite pictures. With 64 ISO film and a 28mm lens, exposure was 1/250 at f/5.6-8.

The Personal Can Be Commercial Too

It is absolutely valid to make travel pictures from a highly personal point of view, whatever your ultimate photographic goals. Obviously, you can shoot anything you want for personal records of travel, and related albums, slide shows, and presentations on the Web, but today, the personal approach may also be your best route to artistic recognition, exhibition in galleries, and even commercial publication.

The more original and particular your photographs are, the better your chances of success, including financial success. You don't want to compete with the far-too-many cookie-cutter travel images already out there.

Of course, to be published in top magazines, succeed in marketing stock images, illustrate travel guides and textbooks, or shoot for commercial travel/tourism accounts, your pictures must be technically excellent. They should be well exposed and well composed, with no cluttered backgrounds, ugly shadows on faces, no large blown-out highlights or impenetrable shadow areas, and the center of interest should be apparent. Most importantly too, travel pictures aimed at commercial clients must almost always reflect the interests of people planning their own vacations and travels, and be upbeat.

Creating Your Portfolio

If you are serious about pursuing photography on a pro- or semi-pro basis, you will need to assemble a portfolio to show to potential buyers. Choose only your best images. Make or have good-quality enlargements made, in sizes ranging from about 11" × 14", 16" × 20", 11" × 17", or 13" × 19". The last two sizes are for a digital printer. A great many photographers print their own inkjet portfolios today. While elegant portfolio covers and cases are nice, good pictures are what make a portfolio stand out. About twenty prints are enough for a small exhibit or a first fine art or commercial portfolio. Read *The Photographer's Guide to Marketing and Self-Promotion* by Maria Piscopo and *The Perfect Portfolio* by Henrietta Brackman for more.

One final piece of advice: If you edit pictures for a gallery exhibit or to create a portfolio to seek professional work, ask for the opinions of others whose taste you respect. In the end, however, always follow your gut instincts. Be sure to include your own favorite pictures in any showing of work, in all likelihood they form the basis for your own personal visual style. Be proud of these photographs.

Editorial Travel Photography

Editorial photography is done for magazines, newspapers, trade, and textbook publishers, and today for noncommercial use on Web sites. The style is usually photojournalistic and looks unposed, even if some situations are "set-up" or re-created versions of situations that have happened or could be expected to occur at that particular place. Editorial travel photography appears uncommercial, though the point of view has to be upbeat; travel magazines pay their expenses with advertising that promotes travel destinations, carriers and cruises, hotels and resorts, national tourist offices, and more. Magazines give assignments generated by their editors to photographers whose work they like

❶

❷

MOUNTAINS

I've seen the Alps, the Andes, the Rockies, the Himalayas, and more, but the North West Frontier province of Pakistan, near the border of Afghanistan, has the most rugged mountain scenery I've ever seen. The inhabitants are a proud and, on my two visits, gracious and hospitable people. File this information away for the day when it will be prudent to visit the area again. (I hope that will be soon.)

❶ I hardly ever take funny pictures, but this one does make me laugh. A stonebreaker in the Karakorams, North West Frontier Province, Pakistan. Nikon FM-2, 28mm lens, ISO 50 film, 1/250 at f/4.

❷ The Canadian Rockies from the Icefields Parkway, British Columbia. Mist makes mountains appear to recede; this is especially effective when shooting in black-and-white. 400 ISO film, handheld 70– 300mm lens. Exposure was 1/500 at f/5.6.

❸ Mount Denali, Alaska, on a rare clear day. Nikon F-100 camera; Ektachrome 100 film; 80–200mm f/2.8 Sygma lens, exposure was 1/500 at f/8–11 handheld and I bracketed.

VARIATIONS

As I've said before, there's more than one picture to be made out of almost any subject. Take time to explore different possibilities.

❶ A brandy advertising sign shot from the side of a highway near Oaxaca, Mexico. I used a Fuji S-2 camera at 400 ISO on a dull gray day. An 80–300mm lens was zoomed to full extension (effectively 420mm). Exposure was 1/500 at f/5.6. I placed the bull off-center for a more interesting composition.

❷ The same sign from the back, same camera and digital setting. The weak sun came from the opposite direction into the lens, so I closed my aperture by one f/stop. Which image do you prefer? I like this one best.

❶

❷

as well as to promising newcomers with interesting styles. Guidebook and textbook publishers commission some work, but buy a lot of stock from picture agencies (see below).

If you want to be published and can write as well as make good pictures, and can come up with good story ideas, start small. If a "feature"—picture-story package—has a strong local twist or "hook" you have an excellent chance of getting published. At first, aim for local newsletters and small newspapers. A few years ago I went to the Galapagos on a cruise ship. Most of the passengers were a group of Smith College graduates and their spouses. (I did not go to Smith.) I palled up with a nice Smith grad, a serious amateur photographer, who photographed well and wrote amusingly about getting close-up views of frigate birds and turtles, and the work of the Darwin Research Station, and also captured a series on the oldest Smith grad scaling a 1,000-foot volcano. She placed the two-page picture story with the *Smith Alumni* magazine.

Try writing about and photographing interesting destinations within the range of a local newspaper or regional magazine's readership. Don't forget the hook. "Shawangunk Valley Hose Company and Auxillaries Tour FDR's Home," for instance, or "Wallkill Girl Scouts Enjoy Wearing Long Shorts in Bermuda," or something similar will almost certainly make the local paper. Then work your way up to placing stories about more distant destinations. You'll accumulate "tear sheets"—actual printed pages—of published work; keep those clippings safe in an album. Then aim domestic- or foreign-travel-related feature stories at publications with larger circulations. Find possible outlets in the annual *Photographers' Market*. You might just end up writing and shooting for some well-regarded magazines and national newspapers. A very good idea is to get to know a place in depth. My friend Patricia Fisher of Washington, D.C., is a successful photographer and good writer but not a travel specialist. She does go to Alaska at least once a year to visit her daughter and now has covered most of the state. She has placed well-illustrated Alaska feature stories with the *New York Times* and the *Milwaukee Journal* among other major publications. Note that model releases are not needed for editorial use—publication inside newspapers, books, and magazines. However, it's good to get releases anyway, because then pictures can be marketed for stock, or for travel or tourism advertising or publicity. Releases make all pictures more valuable, so always get them if you can.

Shooting for Tourism

Tourism photography is done for tour, cruise, and hotel operators, airlines, national, state, and provincial tourist offices, as well as for hotels, resorts, theme parks, rodeos, county fairs, and more. I've done a great deal of this work and find it fun. It's very important not to interfere with the running of any tourism group, and to get on well with both the passengers, who may have paid a lot for their vacation, or with the work of the hard-working staff who make things run smoothly. I am nice to all passengers and guests of course, and super-nice to staff who can make or break a tourism shoot. The pictorial aim is naturalism and an unposed "look." Tourism clients in general are usually best shown as couples or in congenial small groups having a great time in a lovely place, but feel free to add your own interpretations—after you have made the bread-and-butter shots.

Honeymooners are often shown on gorgeous empty beaches, or looking into each others' eyes in upscale restaurants, or romantically entwined at sunset on the deck of cruise ships. You get the idea.

The trick is to render all these clichés fresh, the place as pristine and lovely, and the people as charming and believable. I like best to pick out "real" people and work with them at tourist sites, rewarding them with a drink, meal, or a special excursion if I've spent a lot of time with them. If I promise pictures, I make every effort to send them as soon as possible.

Major Travel and Tourism Subjects

I always try to make the best possible pictures I can of any "icons" that instantly identify a place—city skylines, important buildings, gorgeous scenery in beautiful light—as well as famous streets, especially at twilight, attractive shops and markets, and local specialties. Where possible, I shoot in museum interiors and hotel and restaurant interiors too. These places are important and at the heart of good travel coverage anywhere.

Having captured these iconic sites alone, I don't yet have what makes travel or tourism coverage come alive: pictures of interesting and attractive local people in all walks of life. To me, people pictures are the most important aspect of any travel coverage. To approach people, I use any and all introductions I have, walk around and wait around a lot, and go to places where people are likely to be relaxed and feeling good about themselves. When I have found a willing subject or subjects, I take plenty of pictures of them. Because I know that I will show my subjects only at their best, I feel totally free to ask people to do what I need. For instance, I might ask someone to move out of overhead sun into a shady area, or pretend to shop or look at pictures or do whatever else that seems appropriate and will make the shots look natural. I'm not worried that I will outstay my welcome. Trust me, people will always let you know when they've had enough. (For much more on photographing people, see pages 58–65.)

Commercial Travel Photography

Commercial photography can be for any type of advertising or promotional use, and in travel can be made for airlines or hotel chains, casino or cruises, or can promote a product, such as a car, at a scenic travel destination. I've done some commercial work, mostly for airline promotion, and big-time advertising shoots require a lot of preparation. You will first have to show a portfolio, then submit a bid for the job. If you get the job, your real work is just beginning—the ultimate aim is to capture what the client needs, from your own special point of view.

Big-time shoots are outside the scope of this book, but to learn more, study and analyze travel magazine and newspaper travel sections to give you an idea of what's published. Look at travel television commercials too. I often do that to study great composition, color effects, and lighting by some of the world's highest-paid still photographers, cinematographers, and directors. Remember that all of these specialists were beginners themselves at one time!

Stock Photography

Recently, the stock picture business has embraced digital imagery, and high-quality digital files are now the norm for stock viewing and delivery. The "file size" required by stock agencies or clients may

vary, but "tweaked", color-corrected 32-, 50-, or 72-megabyte "tiff" files are the norm. Individual agencies and clients will let you know their precise requirements of course.

Most reputable U.S. and many good overseas stock agencies are members of PACA, the Picture Agency Council of America. PACA members subscribe to a code of ethics. Their Web site lists members and their specialties, educates clients about copyright, works to establish digital standards, and much more. Find PACA on the Web at *www.pacaoffice.org.*

If you have professional ambitions, know that is not easy to be accepted by a major stock agency, though, of course, almost all are interested in outstanding new talent. Model releases for all images of people and private property are a requirement for acceptance by most agencies today. As a travel photographer your most likely chance of success is if you photograph the life of people in the countries you visit. Be sure to get model releases from all of them. If your collection of travel photographs is highly specialized and model released where needed, contact some of the agencies that might be interested.

An alternative to working with an agency is to market stock for yourself. Set up a Web site to showcase images, or pay to have images posted on a commercial Web site.

If you can, have an experienced Web designer make an eye-catching site for yourself. He or she will know all the tricks necessary to get your site noticed by the major computer search engines. Of course, if you have the skills, design, execute and update a site for yourself.

In terms of the type of pictures to show, while you should certainly photograph famous travel "icons" like Big Ben, the Eiffel Tower, or Venetian canals and gondolas when the opportunity arises, you probably won't sell too many of those shots because famous sites and scenes are well represented on "royalty-free" stock disks. Today, the more individual your style and the more unusual your subject matter the greater your chances of marketing images. Research stock agency and travel photographers' sites on the Internet as a place to start.

There are also individual photographers who successfully create and market their own stock, without the support offered by an agency. These talented and hard-working photographers find clients by showing photographs and listing subjects and specialty areas on their Web sites, by sending out mailings, subscribing to stock "want list" bulletins published by textbook companies and others, advertising in "showcase" books, and more.

Note: *You must get model releases from all people and private property you photograph if the images are to be marketable as stock.* An excellent book on the subject of shooting stock pictures for profit is *How to Shoot Stock Photos That Sell*, by my friend, photographer Michal Heron. Michal is not a travel specialist, but she travels on occasion and is very successful; most of her suggestions can be modified to suit travel photography.

Another worthwhile book, updated annually, is *Negotiating Stock Photo Prices*, by Jim and Cheryl Pickerell. This book is an excellent business as well as pricing guide.

If you are especially interested in marketing travel stock, it's worth reading S*ell and Resell Your Pictures* by Ron Engh. The book has been updated for the digital age.

I personally have made a decent amount of money from travel stock over the years, approaching $300,000 to date, most of it from assignment "out-takes," and in the days before bright-colored "royalty-free" travel stock discs were available. I still market some stock through Photo Researchers, a respected agency here in New York that has represented me for many years, and I love all the people who work there dearly. But the royalty-free discs have definitely cut into my sales of travel stock.

ART AND ARTIFACTS

Be sure to get permission before you photograph important art. Some museums charge a fee for this; others allow some photography but forbid it for special exhibitions. The use of flash is almost never permitted in museums, and on-camera flash is likely to cause bad hot spots on pictures anyway. Tourist art is also fun to photograph—I collect it too.

❶ Detail of mural by Diego Rivera, National Palace, Mexico City, Mexico. The huge mural was day lit and details were easy to photograph. I used my Fuji S-2 and 28mm lens, 200 ISO setting. Exposure was 1/60 at f/4.

❷ Sculpture by Carl Milles in park outside Stockholm, Sweden. I positioned myself so that low afternoon sun was behind the hand. An aperture of f/16 causes any point of light to form a star without a filter. With 100 ISO film exposure was 1/30 at f/16. Sky was darkened with an orange filter.

❸ The Elgin Marbles, British Museum, London, U.K. Photography without flash is okay here.

❹ Copyist at the Louvre, Paris, France. I talked to the artist for several minutes before getting his permission to photograph. S-2 digital camera rated at 400 ISO, 20mm lens. With diffused daylight from overhead, exposure was 1/60 at f/4.

❺ Maiko, or young Geisha, Kyoto, Japan. Tungsten-balanced 160 ISO film rated at 320, FM-2 camera, and handheld 50mm f/1.8 lens. Exposure was 1/60 at f/1.8, handheld by low available light. I later corrected the slide's color balance using Adobe Photoshop.

❻ Orange seller, Jamaica, West Indies. I spent some time talking to this lovely woman before photographing her. Exposure on 64 ISO film was 1/125 at f/5.6.

❼ Float with Virgin and candles, Easter week, Seville, Spain. At night I used a 35mm f/1.4 lens and 400 ISO film rated at 800. It was pitch dark, so I metered off the candles, then opened up the aperture two stops to compensate for the non-average subject. Exposure was 1/60 at f/2.8.

❶

❷

❸

4

5

6

7

PERSONAL, FINE ART, AND DECORATIVE IMAGES

I love to find graphics, strong patterns, and bright colors on my travels. Sometimes these subjects have commercial appeal, sometimes not, but I take them for my soul anyway. I make archival digital enlargements on Epson photo printers, and have sold a few such prints at moderate prices recently. I compose such "art" pictures carefully. What is *not* included is frequently as important as the main subject.

❶ Moored tour boats, Xochimilco, Mexico. Photographed with an S-2 camera, a 100 ISO speed rating, and a 70–300mm lens. Exposure was 1/250 at f/11 in bright sunshine.

❷ Lobster buoys, Maine. I shot these in color.

❸ Balsa-wood birds, Ecuador. I composed carefully to eliminate all but the birds, using a 50mm macro lens on a F-100 camera. With 50 ISO film, exposure was 1/250 at f/8.

❹ An old-fashioned photo studio in Pesharway, Pakistan. Shot in color and transposed into black-and-white.

❺ Tropical fruit, Jamaica, West Indies. S-2 digital camera, 50mm lens, Program mode.

❶

❷

❸

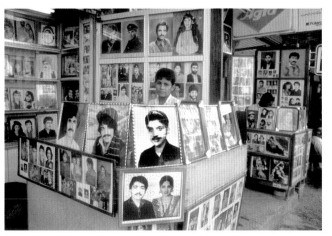

❹

❺

Fine Art Travel Photography

If you visit art museums and photo galleries regularly, as I do, you already know that fine art travel photography can be of any style and can be presented in many different ways. I've seen huge digitally manipulated color prints hung at New York's Museum of Modern Art, and a grouping of about a dozen 4" × 6" mini-lab prints taped directly to the wall in the trendy West Chelsea gallery district of this city. Obviously, I've seen plenty of conventional 11" × 14", 16" × 20", and 24" × 36" black-and-white enlargements exhibited. Digital prints are now exhibited at top museums and have gained acceptance at commercial galleries, too.

The travel/fine art pictures that interest me most often have a haunting, evocative quality. They seem simple while you are looking at them, but later stay in the mind's eye. I remember shots of huge empty rooms in what must once have been the grandest of mansions in Bahia, Brazil, or large, man-made alterations to recognizably Japanese landscapes, both by photographers whose names escape me. As fine art photography is now accepted by museums everywhere, visit exhibits to see beautiful original prints, even if you don't hope to show yourself. And if you do want to exhibit, it's often possible to start with shows at colleges, local museums, libraries, and banks. To have a show, you need to print, mat, and frame at least twenty good pictures.

You will have to present a portfolio of prints and convince a gallery owner that your work will appeal to a fairly wide audience, and then foot most of the above exhibit expenses yourself if you want to show in a top commercial photo gallery.

To Sum Up

So, where do you go from here? Today, you can easily make digital prints in your local superstore, or, invest in a digital printer, or, show your work via e-mail and even on your own Web site. You may prefer to make traditional prints from film negatives or to assemble shows of your best slides. And today, slides and digital images can be copied, scanned and manipulated for showing on computer, and TV screens. (Take computer classes if this approach interests you.) There is no one right or wrong way to approach photography in general, or travel photography in particular. Many professional photographers today do have their own Web sites, soliciting assignments and selling prints through this medium. I hope to get my own site back up soon; look for it at *http://www.susanmccartney.com*. Or, if you wish, contact me in care of my publisher.

Your eventual audience of course will depend on how much time and interest you have to devote to photography and travel. Family and friends, colleagues, local, regional and even national organizations and visitors to galleries and museums will all enjoy looking at well-presented travel photography shows. If you have professional ambitions, go for it, though be prepared to work hard and long to achieve the end of publication in top ads, magazines, and books. Perhaps part-time shooting for stock interests you most; then I strongly suggest that you work closely with a stock agency that is extremely specific about their needs.

See the resources section at the end of the book to find out more on all of the above options. But on any level, if you take your picture taking seriously it will always add immeasurably to your joy in travel.

Resources

U.S. Government Web Sites

The URL for U.S. government travel-related topics is: *www.firstgov.gov/Citizen/Topics/Travel.shtml.*

The U.S. State Department puts out official travel advisories that are updated daily. These plus background papers on over 140 countries, access to health advice, and more are available through: *www.travel.state.gov.*

The U.S. Transportation Security Administration rules for carrying photo equipment onto planes are summarized at: *www.tsa.gov/public/interapp/editorial/editorial_1248.xml.*

Selected Foreign Government Web Sites

These may give different perspectives on current events than the U.S. sites, and I hope will be useful to readers from these and other English-speaking countries.

The Canadian Department of Foreign Affairs and International Trade posts travel advisories and more in English and French on its Web site: *www.dfait-maeci.gc.ca.*

The British Foreign and Commonwealth Office publishes travel advisories and other advice on its Web site: *www.fco.gov.uk/travel.*

The Australian Department of Foreign Affairs and Trade has an official Web site listing current travel advisories at: *www.dfat.gov.au/travel.*

Other Useful Web Sites

Quite a few product- and travel-related Web sites will change their URLs during the life of this book. Space does not permit listing them all, anyway. To find any *current* Web site address, first type *www.google.com* or *www.yahoo.com* into your Web access provider. Then type the name of the company, country, product, or other organization or subject you want to learn more about. Be as specific with your request as possible, or you may be offered dozens or even hundreds of options, not all of which will be germane to your needs. Don't just type "Hawaii," for instance. Type "Official tourist information for Maui, HI," or "National Parks, Hawaii," or "Hotels + Hawaii + Kona Coast." Then, copy and paste the most relevant URL into your Web access provider.

Today, it's easy and often fun to look up airline routes and schedules, bargain and discount fares, hotel rates and locations, and event listings both at home and overseas. You can also locate guidebook sites, national, state, and regional tourist offices, destination maps, and much cultural and other travel information. The following list offers a selection of airlines, hotels, car-rental companies, and other resources to check out online or by phone for current travel deals and information.

Air Canada	Insight Guides
Air France	Japan Airlines
Aero Mexico	KLM Royal Dutch Airlines
Air New Zealand	Lonely Planet Guides
Alamo Rent-A-Car	Lufthansa
Alaska Airlines	Marriott Hotels
Alitalia	Motel 6
American Airlines	National Car Rental
Amtrak	Orbitz
Avis Rent-A-Car	Pacific Area Travel Association
Best Western Hotels	Priceline
British Airways	Quantas
Budget Rent-A-Car	Red Roof Inns
China Travel Service	Regency Cruises
Carnival Cruise Lines	S.A.S.
Comfort Inns	Southwest Airlines
European Travel Commission	State Tourist Office of (place)
Expedia	Travelocity
Government Tourist Office of (place)	T.W.A.
Hawaiian Airlines	United Airlines
Hertz Rent-A-Car	U.S. Airways
Hilton Hotels	Varig Airlines
Holland America	Virgin Atlantic Airways

Selected Catalogs

B&H Photo Video: sourcebooks and catalogs; retail store in New York City; *www.bhphotovideo.com.*

Calumet: excellent catalogs; retail stores in Chicago, Los Angeles, New York, Philadelphia; *www.calumet.com.*

Light Impressions: albums, archival storage for digital and film images; *www.lightimpressionsdirect.com.*

Helix Camera: books, equipment, supplies, and underwater photo catalogs; *www.helix.com.*

Selected Manufacturers

Photographic Bags and Cases

Lightware Inc., *www.lightwareinc.com*

LowePro USA, *www.lowepro.com*

Pelican waterproof bags and cases, *www.pelican.com*

Tamrac bags and cases, *www.tamrac.com*

Tenba Quality Cases Ltd., *www.tenba.com*

Digital and Film Cameras, Lenses, and Accessories

Canon USA, *www.usa.canon.com*

Fuji USA, *www.fujifilm.com*

Konica Minolta, *www.minoltausa.com*

Nikon USA, *www.nikonusa.com*

Pentax USA, *www.pentaxusa.com*

Sigma, *www.sigmaphoto.com*

Tamron lenses, *www.tamron.com*

Tokina lenses, *www.thkphoto.com*

Digital Media Cards, Card Readers, and Portable Image Storage

Lexar Compact Flash cards, Memory Sticks, card readers, and more, *www.lexarmedia.com*

SanDisk Compact Flash cards, Memory Sticks, and more, *www.sandisk.com*

Flash Trax Portable image storage devices, *www.smartdisk.com*

LaCie High-capacity pocket hard drives, and more, *www.lacie.com*

Digital Photo Printers

Canon, *www.usa.canon.com*

Epson, *www.epson.com*

Film

Agfa, *www.agfanet.com*

Eastman Kodak, *www.kodak.com*

Fuji, *www.fujifilmusa.com*

Ilford, *www.ilford.com*

Lead-Foil Film Protector Bags

Sima Products: also digital-image storage banks, and more, *www.simaproducts.com.*

Photo Manipulating/Retouching Computer Software

For PCs and for Macs with System OS X: ACDSee, *www.acdsystem.com*

For Macs and PCs: Adobe Photoshop and Adobe Photoshop Elements, *www.adobe.com*

For Macs only: i-Photo: *www.apple.com*

Portable Lighting and Accessories

Chimera collapsible soft light boxes, *www.chimeralighting.com*

Lumedyne portable flashes, batteries, and accessories, *www.lumedyne.com*

Metz flashes, *www.bogenphoto.com*

Sekonic handheld flashmeters, *www.sekonic.com*

Wein Saf-sync and flash trigger and slave units, *www.products.com*

Tripods, Clamps, and Light Stands

Manfrotto and Gitzo Tripods, Bogen Photo, *www.bogenphoto.com*

Selected Photo Books and Magazines

Mastering Flash Photography, Susan McCartney (New York: Amphoto Books, 1995). For some of my other books, see the last page of this one!

Outdoor Photography Magazine

PDN (formerly *Photo District News*), *www.pdn.com*

The Rangefinder Magazine

Shutterbug Magazine

Selected Guidebook Series

AAA USA State Guides (free to members), *www.aaa.org*

Insight Guides, *www.insightguides.com*

Lonely Planet Guides, *www.lonelyplanet.com*

Selected Travel Magazines

Condé Nast Traveler

Islands

National Geographic

National Geographic Traveler

Outdoor Photography

Travel and Leisure

Travel Holiday

Sample Gray Card (Approximate)

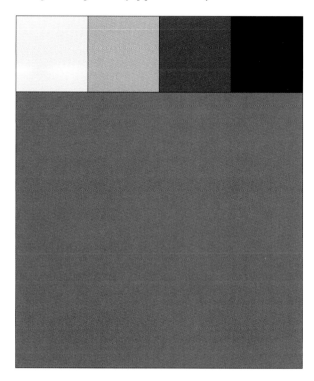

ELECTRIC PLUGS WORLDWIDE

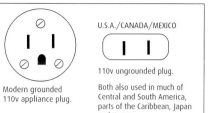

U.S.A./CANADA/MEXICO

110v ungrounded plug.

Modern grounded 110v appliance plug.

Both also used in much of Central and South America, parts of the Caribbean, Japan and Korea.

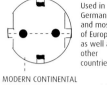

Used in Germany and most of Europe as well as other countries.

MODERN CONTINENTAL APPLIANCE PLUG, 220-240v, with recessed grounding contacts at top and bottom.

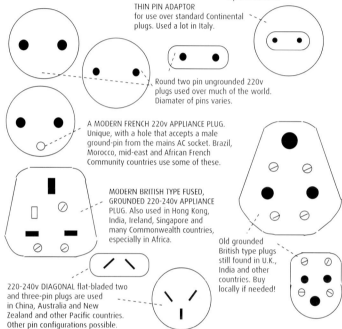

THIN PIN ADAPTOR for use over standard Continental plugs. Used a lot in Italy.

Round two pin ungrounded 220v plugs used over much of the world. Diamater of pins varies.

A MODERN FRENCH 220v APPLIANCE PLUG. Unique, with a hole that accepts a male ground-pin from the mains AC socket. Brazil, Morocco, mid-east and African French Community countries use some of these.

MODERN BRITISH TYPE FUSED, GROUNDED 220-240v APPLIANCE PLUG. Also used in Hong Kong, India, Ireland, Singapore and many Commonwealth countries, especially in Africa.

Old grounded British type plugs still found in U.K., India and other countries. Buy locally if needed!

220-240v DIAGONAL flat-bladed two and three-pin plugs are used in China, Australia and New Zealand and other Pacific countries. Other pin configurations possible.

Index

Books from Allworth Press

Allworth Press is an imprint of Allworth Communications, Inc. Selected titles are listed below.

Mastering the Basics of Photography
by Susan McCartney (paperback, 6¾ × 10, 192 pages, $19.95)

Photographic Lighting Simplified
by Susan McCartney (paperback, 6¾ × 9⅞, 176 pages, $19.95)

Mastering Nature Photography: Shooting and Selling in the Digital Age
by John Kieffer (paperback, 6 × 9, 288 pages, includes CD-ROM, $24.95)

Creative Canine Photography
by Larry Allan (paperback, 8½ × 10, 160 pages, $24.95)

Talking Photography
by Frank Van Riper (paperback, 6 × 9, 320 pages, $19.95)

The Real Business of Photography
by Richard Weisgrau (paperback, 6 × 9, 256 pages, $19.95)

Starting Your Career as a Freelance Photographer
by Tad Crawford (paperback, 6 × 9, 256 pages, $24.95)

Photography Your Way: A Career Guide to Satisfaction and Success
by Chuck DeLaney (paperback, 6 × 9, 304 pages, $18.95)

Mastering Black and White Photography, Revised Edition
by Bernhard J Suess (paperback, 6¾ × 9⅞, 256 pages, $19.95)

Creative Black-and-White Photography: Advanced Camera and Darkroom Techniques, Revised Edition
by Bernhard J Suess (paperback, 8½ × 11, 200 pages, $24.95)

Historic Photographic Processes
by Richard Farber (paperback, 8½ × 11, 256 pages, $29.95)